zen doodle
tons of tangles

edited by TONIA JENNY and AMY JONES

NORTH LIGHT BOOKS
Cincinnati, Ohio
CreateMixedMedia.com

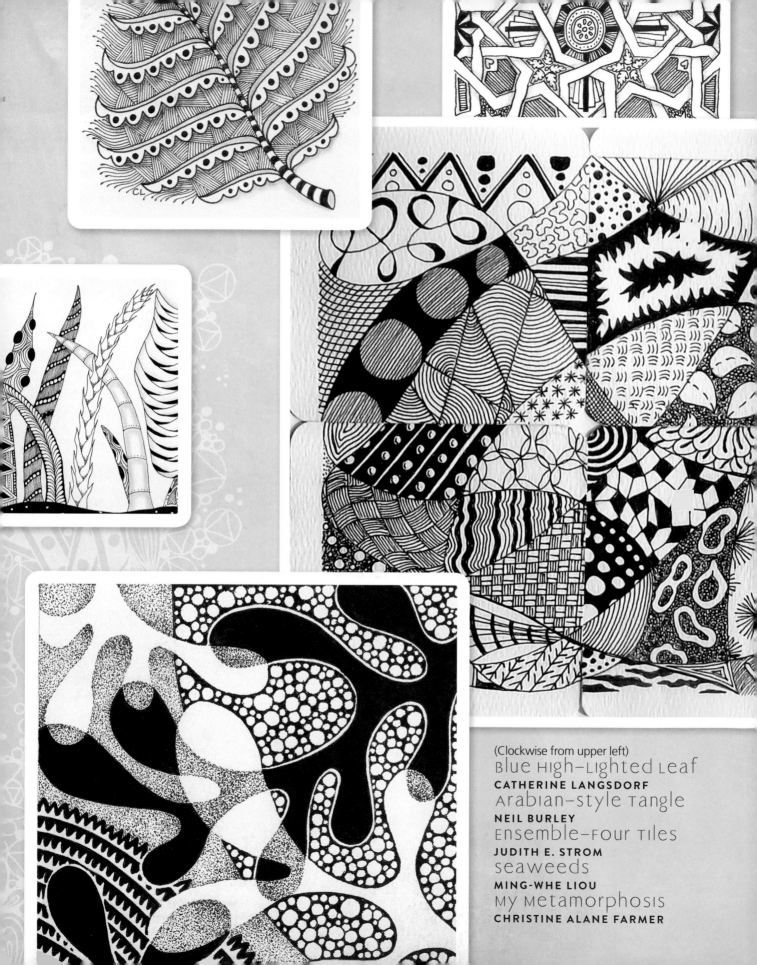

(Clockwise from upper left)
Blue High-Lighted Leaf
CATHERINE LANGSDORF
Arabian-style Tangle
NEIL BURLEY
Ensemble-Four Tiles
JUDITH E. STROM
Seaweeds
MING-WHE LIOU
My Metamorphosis
CHRISTINE ALANE FARMER

contents

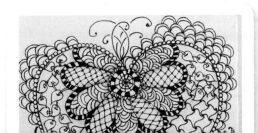

(Top to bottom)
Dancing in the wind
MING-WHE LIOU
Heaven
KATHIE GADD

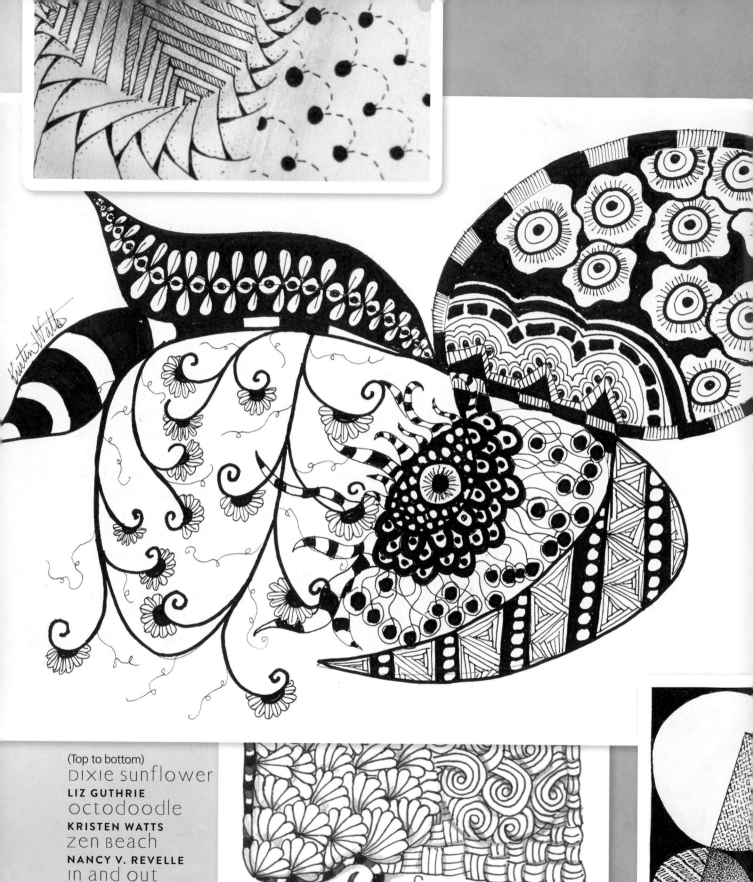

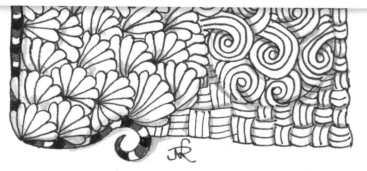

(Top to bottom)
DIXIE SUNFLOWER
LIZ GUTHRIE
OCTODOODLE
KRISTEN WATTS
ZEN BEACH
NANCY V. REVELLE
IN AND OUT
MING-WHE LIOU

Introduction

zen: An aim at enlightenment through meditation.

doodle: An aimless scribble.

While this act of intuitively making the art we have come to refer to as Zen doodling definitely creates a relaxed, meditative state, we think we can safely say that it is anything but aimless. Boardroom-meeting doodling may be aimless but, Zen doodling creates a sense of awareness and intention.

When we put out a call for art for this book, we knew the art form was crazy popular, but we weren't prepared for how difficult it was going to be to narrow down the amazing work that was submitted. While many of the patterns and marks seen in Zen doodle art are ancient in origin, the creative compositions you're about to feast on here are fresh, fun and delightfully inspiring.

The possibilities of Zen doodling are endless, but we did manage to organize the incredible contributions into four chapters to get your tangle wheels turning: "Abstract Doodles," "Shape and Objects," "Animals and Beasts" and "Friendship and Love." We think you're going to love each one!

Whether you're a seasoned Zen doodler or someone who has yet to get her feet wet, we know you're going to find more inspiration on these pages than you ever imagined, thanks to the generous instruction provided by this collection of artists.

It's time to find your favorite pen and get lost in the doodle!

—Tonia and Amy

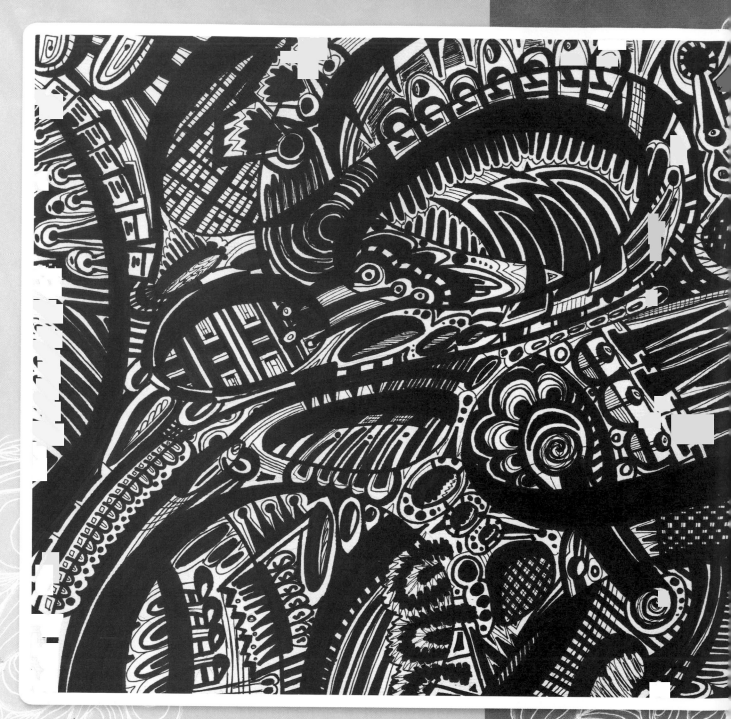

paths
ELIZABETH SNOWDON

12" × 18" (30.5cm × 45.7cm)
Sharpie marker on heavy-weight textured paper

Like many artists, I started Zentangling on tiles. I quickly became bored with the size, so I grabbed my biggest pad of paper and a handful of Sharpie markers and went to town. My anxieties melted away with each squeak of the felt tip, and before I knew it, I had filled the page. This doodle is entitled *Paths* because this size experiment was more about the journey than the destination.

chapter one

Abstract Doodles

Many Zen doodle designs begin with a planned shape or form in mind, such as the work you'll see in the chapters to follow. Other times, the approach is more abstract with less attachment to the form the art will take on naturally.

The process often begins as a pebble hitting the surface of the water, and patterns ripple out and emerge as the pen flows and the composition grows. Suddenly we look up and realize we've been in "the zone" with no sense of how much time has passed. Elizabeth Snowdon puts it nicely: "My anxieties melted away with each squeak of the felt tip, and before I knew it, I had filled the page."

As you'll see from the art in this chapter, a repeating pattern need not be confined to an identifiable or symmetrical shape. It's as if the art is a living, breathing thing, growing with its own agenda, like a wild vine along a trellis. However, we think you'll agree that whether neatly confined or left to run wild, all of the designs here are an abstraction of creative genius!

Layers
KARI DEEBLE

3½" × 3½" (8.9cm × 8.9cm)
Sakura Pigma Micron pen 01, Zig Millennium 05, graphite pencil on heavyweight drawing paper

I used the patterns *Paradox, Cheers, Wavy Border* (variation), *Rain, Sprocket*, a chevron design of my own and *Hollibaugh* to create this tile.

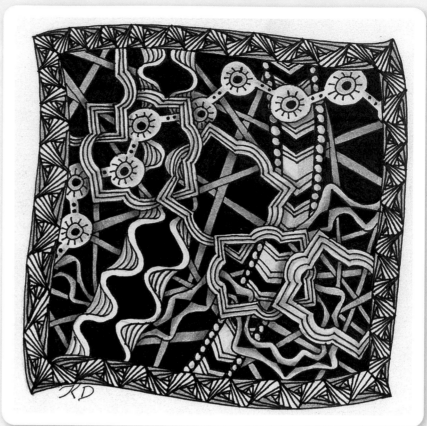

1 Pencil in rectangles with arches, and take a few minutes to decide which parts are going over and which parts are going under.

2 Add ink to the sections that are over, then ink the under sections, making sure not to draw on top of previously completed sections. Add triangles in the border, and fill them with *Paradox* (alternating the line directions to get the shell pattern) to complete the frame.

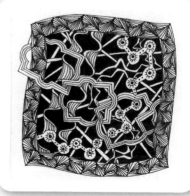

3 Add several border designs behind the main frames, and use *Hollibaugh* in the background to complete the drawing. Finally, add shading with a pencil to emphasize the 3-D aspect of the design.

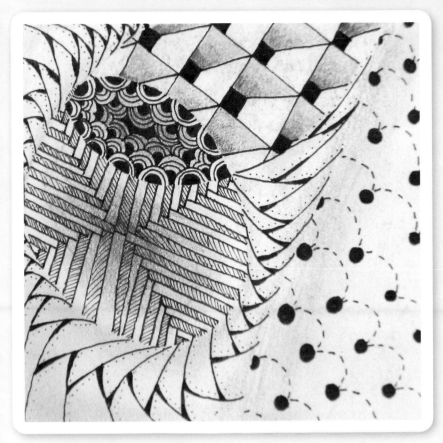

DIXIE sunflower
LIZ GUTHRIE

3½" × 3½" (8.9cm × 8.9cm)
Sakura Pigma Micron pen 005 Black,
graphite pencil, Strathmore 80-lb.
(120gsm) drawing paper

I created *Dixie Sunflower* on a cold
February morning in New England
when I was craving a little sunshine.
The bouncing ball pattern on the
right side of the tile was inspired by a
TV show I was watching at the time,
and I now refer to it as Lilypad.

*"create art that
makes you happy,
and you're sure to
find that it has a
similar effect on
others."*

—LIZ GUTHRIE

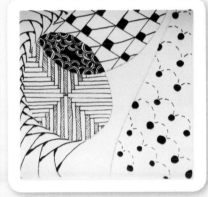

1 Create a string including a
section with overlapping ovals,
serving as the center of your
flower. Fill the center with a
dark, seed-inspired pattern
(example: Zentangle's®
Crescent Moon), rotating your
paper as you work around the
oval. Begin filling a neighboring
section of the string with a
pattern that lends itself to
dramatic shading.

2 Complete the center of your
flower. I chose a pattern that
visually divided my larger
oval section into four smaller
sections. Fill in a large, open
section of your string with a
light pattern.

3 Create the petals with a
braid-inspired pattern such as
Zentangle's® *Betweed*. Starting
in a small corner, connect
the left side to the right with
a short, slightly arched line.
Then connect the left side to
this arched line with a similar
line. Continue in this manner,
rotating as you go.

FISH IN FLIGHT
HANNAH O. KOCH

3½" × 3 ½" (8.9cm × 8.9cm)
Black pen on paper

My inspiration for creating this tile was a personal challenge to see if I could incorporate subtle, animal-like features through the doodling process. For this particular tile, I wanted to combine the similar features of a fish and a bird.

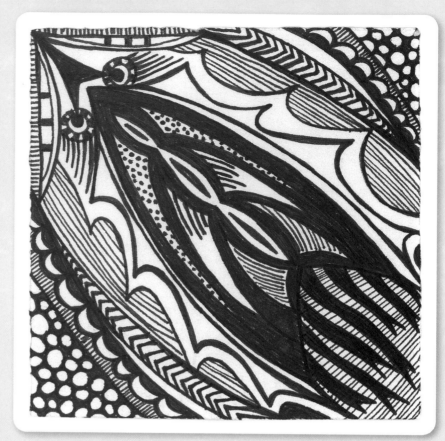

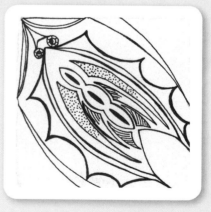

1 Begin by drawing your favorite shape on point. Once drawn, go over the line two or three times. This will vary the thickness of the line.

2 Next draw inside the shape. For this tile, I chose to start in the center of my large shape with another shape that resembles the top view of fins. Once the inside of the shape is almost filled with a variety of doodles, think about where eyes could be placed on the outside of the shape. Just the suggestion of eyes could be all you need.

3 Once the eyes are in place, doodle shapes that could be considered the creature's body. One way to do this is to mirror your doodles from one side of the shape to the other, remembering that it does not have to be perfect. For this particular tile, I inverted the mirrored image from one side of the shape to another.

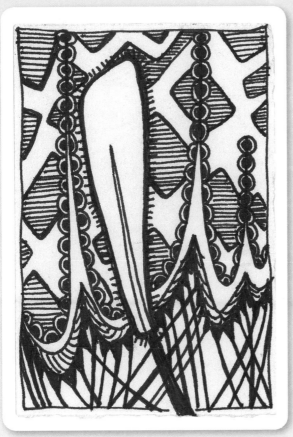

PADDLE THROUGH LIFE
HANNAH O. KOCH

3½" × 2⅜" (8.9cm × 6cm)
Black pen on paper

For this tile, I wanted to draw a shape that could be the combination of a feather and a paddle. I also knew I wanted this shape to be upright and not as you would typically see a paddle.

"Don't just look at your surroundings; look through those surroundings for the overall shapes that appeal to your inner creativity."

—HANNAH O. KOCH

1 Begin by drawing an elongated shape leaning to one side of the tile, and then go over the line two or three times. This will vary the thickness of the line.

2 Add another shape that overlaps the paddle and extends off the bottom edge of the tile. Add a border around the edge of the tile, taking care to not overlap the shape at the bottom of the page.

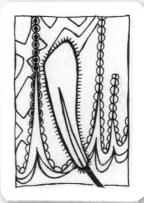

3 Draw a border around the paddle that is not a closed shape. Next draw a wave-like line that goes behind the paddle to separate the top and bottom of the tile. Draw small, closed shapes on the line, and then add large, grid-like shapes in the background. Add a different pattern below the wave-like line to complete this tile.

Dancing in the wind
MING-WHE LIOU

3" × 3" (7.6cm × 7.6cm)
Extra-fine and medium-size black markers on regular printer paper

I wanted to try the eye-pleasing design of spiral and winding vine, while avoiding a deliberately decorative style.

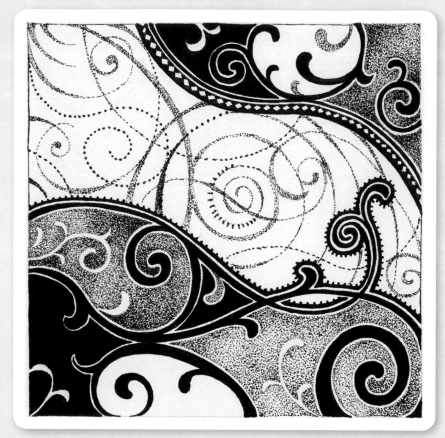

1 On the top and bottom of a blank square, draw some curved lines as a basic layout, and gradually increase their thickness to a balanced volume.

2 Make different trim patterns on the edges of the upper and lower wave. Add stippling to unify the small details.

3 Define some areas by adding black, white and gray shades, and continue to stipple by rolling, twisting and spiraling lines in the empty background. By doing so, these flowing ribbons echo the gentle movement of the main composition.

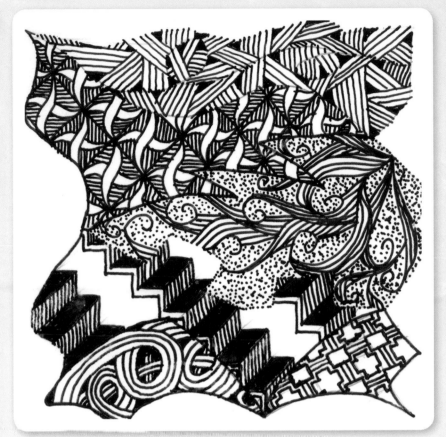

zentangle #2
ROBERT H. STOCKTON

3½" × 3½" (8.9cm × 8.9cm)
India ink on Yupo smooth-finish 74-lb.
(200gsm) acid-free paper

The Zentangle patterns that I selected for this tile are as follows (top to bottom, left to right): *Baton, Meo, Scrolled Feather, Escalator, Sand Swirl* and *Screen.*

"Begin without knowing; inspiration and insight will follow."

—ROBERT H. STOCKTON

1 Draw an irregular outline that incorporates both angular and curved elements. The string I created inside the tile reflected these angles and curves. Begin inking, starting at the top of the tile, using the pattern *Baton.*

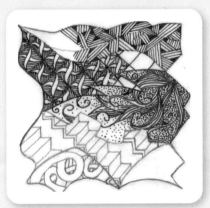

2 Working from the top down, pencil in a grid in the second section for the pattern *Meo,* and ink it in. Add contrasting patterns as a design element in the third section. The white of the paper surrounding this pattern created a visual distraction, so I used pointillism to create a background texture.

3 In the next section, use pencil to lay out the stair steps for *Escalator,* ink it in and finish the tile by completing the two remaining sections using *Sand Swirl* and a variation of *Screen.*

shells 'N such

NANCY V. REVELLE

3½" × 3½" (8.9cm × 8.9cm)
*Zentangle® tile (fine vellum surface),
Sakura Pigma Micron Pen 01 in black,
graphite pencil*

I am a long-time collector of sea-shells, and they represent some of my favorite shapes. I started this tile with a nautilus-shaped string and filled it with the pattern *Cockles & Mussels* as well as a splash of *Diva Dance*. I also used *Keeko* for a stable background along with *Hibred* and *Hurry*. Organic flourishes of *Chain-lea* and *Aura-Leah* with a splash of *Flux* complete the tile.

"words have wings, so speak good things."
—**NANCY V. REVELLE**

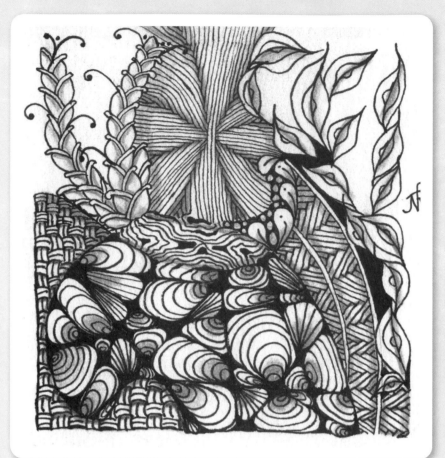

1 | Lay a rough string with pencil as shown.

2 | To fill the nautilus shape, begin with random straight lines which ideally intersect to create triangles. Round off each corner of these sections. Within these rounded sections, create an anchor circle in one corner or on one edge, and draw auras around them to create the shells.

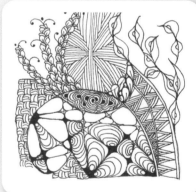

3 | Blacken the areas where the shells come together.
To the right side of the tile, *Hibred* consists of two or three sets of parallel lines in a zigzag pattern.
Finish the various patterns, erase any string lines that are visible and shade with a pencil and tortillon.

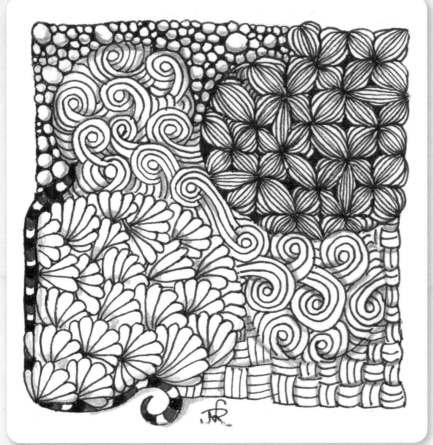

zen beach
NANCY V. REVELLE

3½" × 3½" (8.9cm × 8.9cm)
Zentangle® tile (fine vellum surface),
Sakura Pigma Micron Pen 01 in black
and 05 in red, graphite pencil

For this tile, I wanted to create a beach theme and started with a simple, diagonally mirrored string. I used patterns that represented the seashore in either name or appearance: *Sand Swirl, Sanibelle, Tipple, Keeko, Socc* and a curvy *Barber Pole* variation, which mimics a snake.

1 Draw a string with pencil that mirrors itself diagonally as shown.

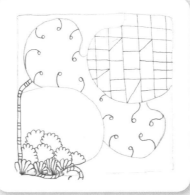

2 Lay out the patterns. The *Barber Pole* snake is laid first to establish the border. The upper-right string gets a basic grid with a few odd diagonals thrown in. Gently curved "inflations" are added to the center, one after another, to each line segment.

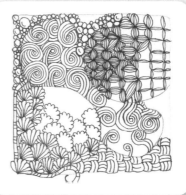

3 Fill in the patterns, being conscious of what lies on top near the area edges. (It's okay to go over the string mark!) Use auras to fill gaps in the center. Color the snake with red and black striping. Erase any string lines that jump out at you and shade with a pencil, softening with a tortillon.

ZT #41
JUDITH E. STROM

3½" × 3½" (8.9cm × 8.9cm)
*Black Pilot Precise V5 extra-fine pen
on watercolor paper*

I keep a stack of watercolor paper
tiles at my desk so I can tangle
whenever the mood strikes me. I
find it very meditative and relaxing.
This tile explores straight versus
curved lines.

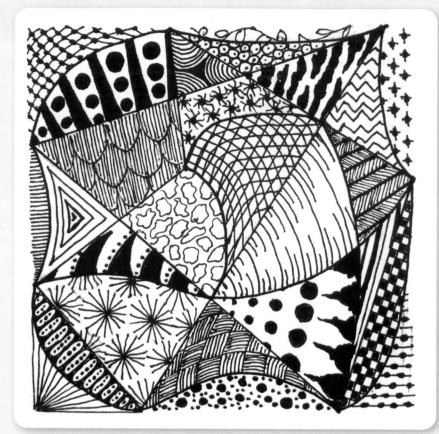

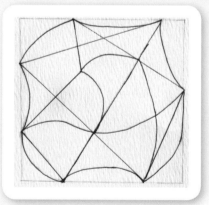

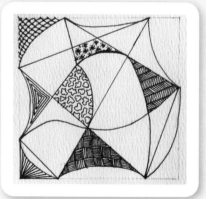

1 Create a 3" × 3" (7.6cm × 7.6cm) square border using a pencil.

2 Create a string inside the border using both curved and straight lines.

3 Then fill each space with a favorite pattern. Once completed, use a gum eraser to remove the pencil lines.

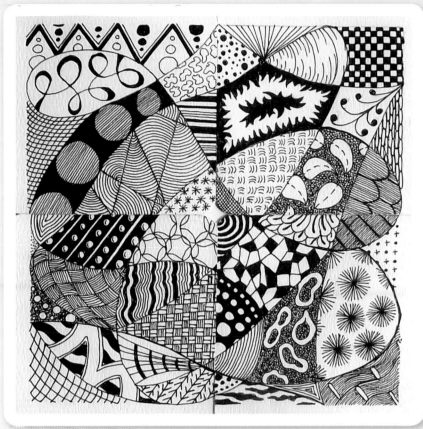

ENSEMBLE—FOUR TILES
JUDITH E. STROM

7" × 7" (17.8cm × 17.8cm)
Black Pilot Precise V5 extra-fine pen on watercolor paper

Ensembles (multiple tiles together) are great fun due to the surprise element. I always tangle each tile separately without reference to the others. The final reassemble is always a moment of anticipation and a delightful surprise.

1 For a four-tile ensemble, start with a 7" × 7" (17.8cm × 17.8cm) piece of paper. With a pencil draw the large 6¼" × 6¼" (15.9cm × 15.9cm) square.

2 Next draw your string across the entire area. Then lightly draw the lines to divide the paper into four 3½" × 3½" (8.9cm × 8.9cm) squares. Notice that each tile will have a border on two sides. Number the tiles on the back so you can reassemble them correctly.

3 Cut the tiles apart and round the corners. Then proceed to tangle each tile separately. When all the tiles are finished, carefully erase all pencil lines. Now reassemble the tiles into a whole. Voila!

Fabrication
EDWINA SUTHERLAND

3½" × 5" (8.9cm × 12.7cm)
Roller Grip liquid ink pen .01 black, 2B pencil on drawing paper

As a textile artist, the patterns and structures of fabrics fascinate me—the holes in lace, the folds of fabric and the patterns of the cloth. Incorporating these in my piece is always very satisfying.

"open yourself to the creative possibilities in every day. it's not just having the idea; it's forming an intention to take the next step along the path of your creative journey."

—EDWINA SUTHERLAND

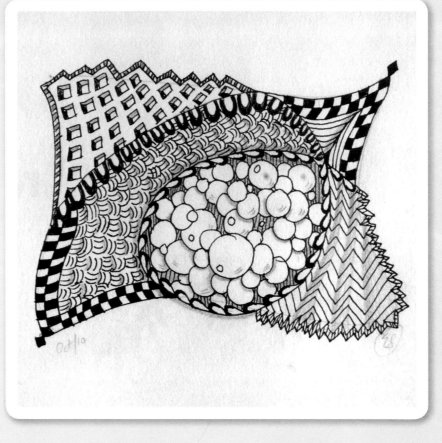

1 Draw the rectangle and a loopy swirl across the tile. Add patterns to the borders, defining the sections of the tile.

2 Fill in the sections with the patterns. Look for movement and flow.

3 Add bubbles and background stripes. Deepen some of the outlines.
 The *Keeko* woven pattern and pencil shading add more depth to the piece.

woven dreams
EDWINA SUTHERLAND

4" × 5½" (10.2cm × 14cm)
*Roller Grip liquid ink pen .01 black,
2B pencil on drawing paper*

This piece was inspired by
the corsets I was making for
reproduction costumes. Hand
stitching and lace are echoed in
the Zentangle.

1 Draw a rectangle in pencil, and
add a zigzag string across the
tile. Begin writing across one
section, and then write over the
first layer in another direction.
This captures thoughts and also
conceals them.

2 Add pearls (circles shown next
to the writing) and lace (along
the bottom) borders, and begin
to fill in a roof tile pattern in
one section.

3 Draw the shoestring lacing in
one section, build up bubbles in
another and add wavy lines to fill
in with ink in the final section.
 Pencil shading adds depth to
the *Love Letters* tile pattern.

kabbage
MELODIE DOWELL

11¾" × 8¼" (28.6cm × 21cm)
*Rhodia dotpad, Sakura Pigma
Micron pens*

I am inspired by Sandra Strait from the Zentangle group on Flickr. She is a wonderful teacher. This is her tangle pattern and my first attempt at it.

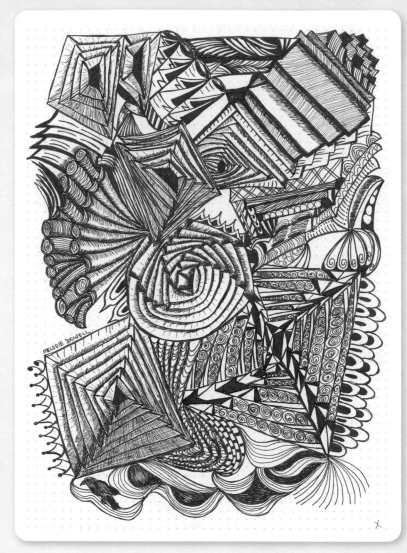

1 First draw an off-kilter square. Then draw a line straight out from each corner. Connect the ends of the lines.

2 Then draw another line slightly off from the first line, always to the right of the original line. Connect those lines.

3 Continue drawing the lines slightly off, then connecting them. Be very careful to put them on the same side each time. Add shading with a pencil or crosshatching with ink as desired.

Sign up for our free newsletter at **CreateMixedMedia.com.**

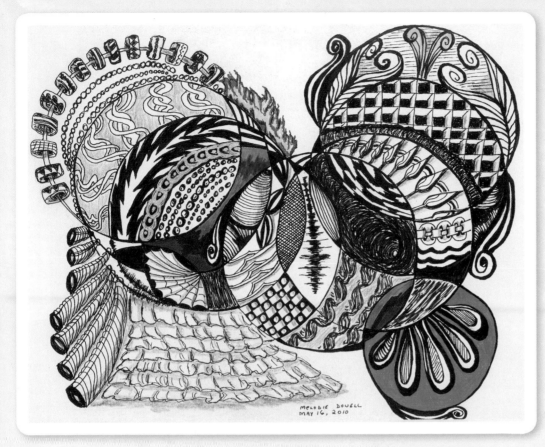

clothes catalog
MELODIE DOWELL

8" × 10" (20.3cm × 25.4cm)
Drawing pad, Sakura Pigma Micron pens, pencil, markers, colored pencils

My inspiration for this was a clothing catalog that came in the mail. I tried a lot of different ways of coloring it, and I used pencil for shading. For the instruction tile, I picked the little blocks with the circles in the center circle.

1 First draw a net with one rounded side because it is the edge of a circle. Make the squares in the netting.

2 Draw a circle in every other square.

3 Use ink to fill in the area around the circles. Then, use your pencil to shade in the right side of each row, creating an interesting shadow effect.

sharlarelli
DEBORAH A. PACÉ

3½" × 3½" (8.9cm × 8.9cm)
Zentangle® tile, Sakura Pigma Micron pen 01, Sakura Gelly Roll Clear Star pen

I was going for an underwater, flowing seaweed-like effect, and this is what came out of the original idea. I find that when I start, I may end up with a very different image than what I was originally going for. They seem to have a mind of their own.

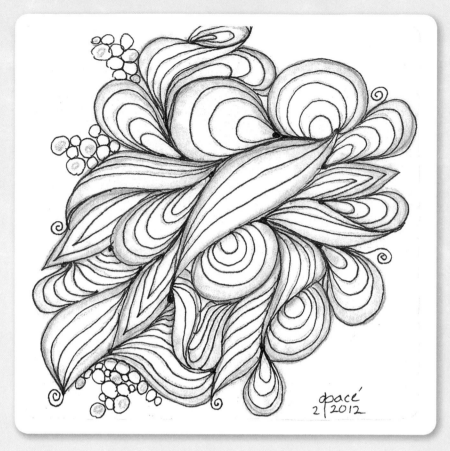

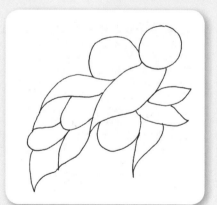

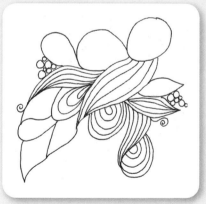

1 Start with a leaf shape, as shown in the center. Then continue with more leaf shapes and a circle.

2 Continue drawing more circles, oval, loops, leaves—whatever shapes appeal to you.

3 Now add lines inside your shapes. Add some swirls and bubbles, as many or as few as you would like.

Sign up for our free newsletter at CreateMixedMedia.com.

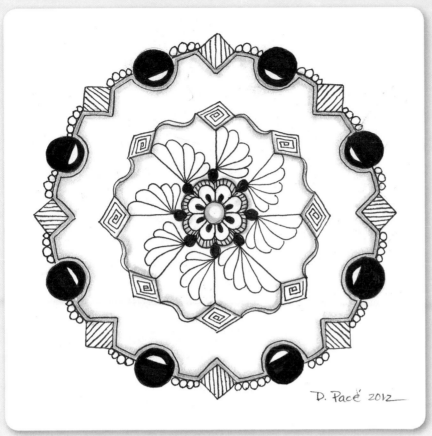

D. Pacé 2012

phases of the moon zendala
DEBORAH A. PACÉ

5" × 5" (12.7cm × 12.7cm)
Bristol smooth vellum paper, Sakura Pigma Micron pens 005, 01, 08

The inspiration for this Zendala was a paper snowflake. I cut out a paper snowflake, and the cutout parts of the snowflake were my strings.

1 With a pencil, mark an "X" and then a cross on your tile. With a compass, draw a 2½" (6.4cm) diameter circle and 4" (10.2cm) diameter circle. Using a pen, draw a small center circle. Around the outside of the circle, draw 8 petals. Draw 8 more petals on the inside of the petals just drawn, and color them in.

2 Draw another line around each petal. Draw small black circles between each petal. Draw diamonds around the inner circle at each straight line. Do the same for the outer circle. Erase the pencil lines.

3 Connect the diamonds from the inner circle to the black circles with a straight line. Draw moons between the diamonds on the outer circle. Connect the diamonds and moons with a straight line. Draw another line around the inside of the diamond and moon shapes. Continue adding fine details and color as desired.

so retro zendala
DEBORAH A. PACÉ

5½" × 5½" (14cm × 14cm)

Bristol smooth vellum paper, Sakura Pigma Micron pens 005, 01, 08

The inspiration for this Zendala was a paper snowflake. I cut out a paper snowflake, and the cutout parts of the snowflake were my strings.

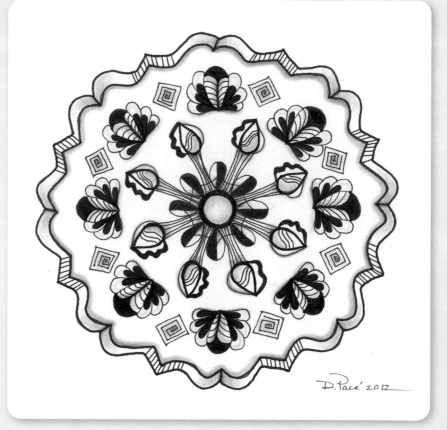

D. Pacé 2012

1 With a pencil, lightly draw an "X" and a cross on the tile. Draw a small inner circle, and with a compass, draw 2½", 3½" and 4½" (6.4cm, 8.9cm and 11.4cm) diameter circles.

2 From the center circle, draw 8 petals using a pen. Between these draw 8 long-stemmed flowers. Notice how the tips touch the first inner circle.

3 Draw diamonds around the middle circle and a decorative line around the outer circle. Erase all pencil lines. Continue to add to your design as desired.

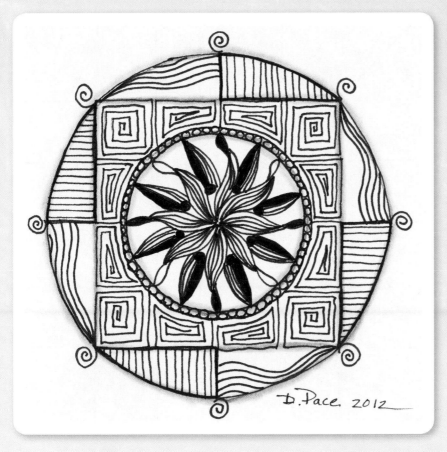

zendala

DEBORAH A. PACÉ

3½" × 3½" (8.9cm × 8.9cm)
*Bristol smooth vellum paper, Sakura
Pigma Micron pens 01, 08*

I am really into creating Zendalas.
I was having a stressful day, and
to relieve some of the stress I was
feeling, I sat down to do this piece.
The basic form of most Hindu and
Buddhist mandalas is a square within
a circle with a center point, which
often exhibits radial balance.

1 With a pencil, draw 2 lines that
intersect at the center of the
square. Using a compass, draw
1½" and 3" (3.8cm and 7.6cm)
diameter circles.

2 Mark the center point. Draw
another circle around the
outside of the inner circle. Draw
a square between the inner
and outer circle. Draw 4 lines
between the square and the
outer circle to mark the center
lines. Erase the pencil lines.

3 Now add a center design and
some circles, lines and swirls.

psychedelic flow
DEBORAH A. PACÉ

3½" × 3½" (8.9cm × 8.9cm)
Bristol smooth vellum paper, Sakura Pigma Micron Pen 01, Sakura Gelly Roll Classic and Moonlight Pens

I just purchased the Sakura Gelly Roll Classic and Moonlight Pens. I wanted a tangle I could use to try out the colors, so I created this tile with lots of loops and swirls to color in.

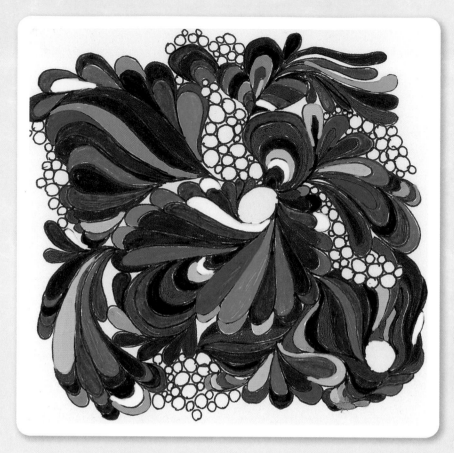

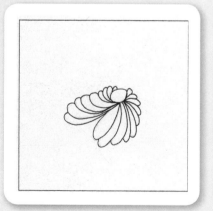

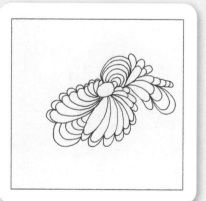

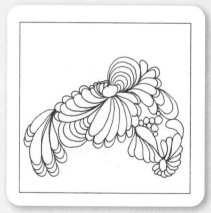

1 Start with a circle in the center. Then add loops around the center circle.

2 Continue to add more loops and loops on top of loops.

3 Add another circle and make loops around it, connecting them with the other loops. Continue to add loops until you are satisfied with the look. Add circles to fill in the spaces between the loops, and then color as desired.

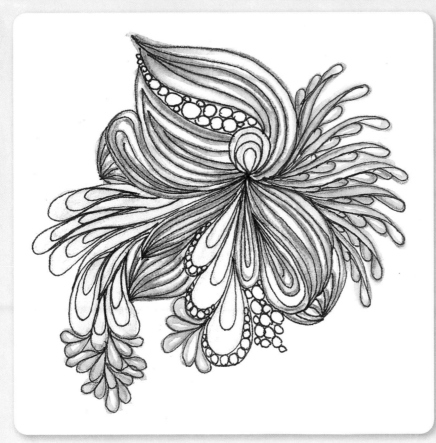

underwater seaweed

DEBORAH A. PACÉ

3½" × 3½" (8.9cm × 8.9cm)
Zentangle® tile, Sakura Pigma Micron pens 005, 01, Prima watercolor pencils

For this tangle, I was playing with loops and lines. Usually, but not always, I start with a circle or something in the center to work from, and then continue to add more circles, loops or lines.

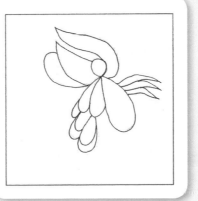

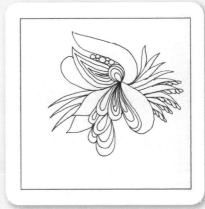

1 | Start with a small circle in the center. Add some loops.

2 | Continue to add more loops and lines.

3 | Now add loops to your lines and lines within your loops. Add some bubbles, and using watercolor pencils, color as desired.

googly-eyed zendala

DEBORAH A. PACÉ

3½" × 3½" (8.9cm × 8.9cm)
Zentangle® tile, Sakura Pigma Micron Pen 01, Sakura Stardust Gelly Roll Pen

I started playing around with lines. I made a circle and drew a series of scallops around the edge, then a flower in the middle. I drew circles with a black dot at each tip of the flower and when I was done, the flower looked like it had googly eyes.

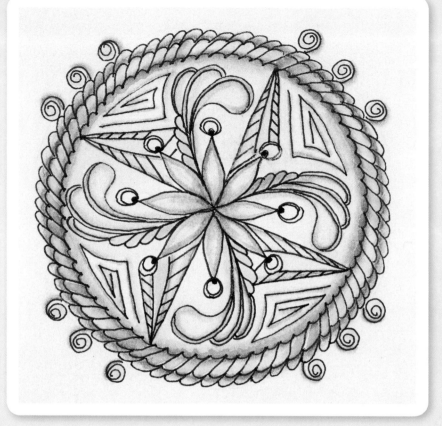

1 Find the center point of the tile, and use a compass to lightly draw a 2½" (6.4cm) diameter circle. With a pen, draw 3 rows of scallops around the circle. Erase the pencil lines.

2 Draw an 8-pointed flower in the center. Draw googly eyes on the tips.

3 Between every other petal, draw a flourish and a series of shapes and lines. Embellish with curlicues around the outside of the circle. Color your design.

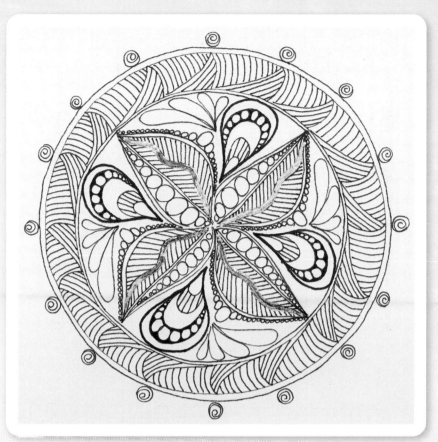

Foiled Leaves Zendala

DEBORAH A. PACÉ

4¾" × 4¾" (12.1cm × 12.1cm)
Stonehenge printing paper, Sakura Pigma Micron pens 005, 01, 08, multi-color foil

With this Zendala, I started with the outer circles first because I was not sure what I was going to do in the center. Zendalas are typically started from the center point out, but I sometimes find starting from the outside and working toward the center is a better way for me to begin my Zendalas.

1. Find the center point on the tile, and draw a 3" (7.6cm) diameter circle using a compass. Draw another line around the outside of this line. The space can be as wide or as narrow as you like. Now draw a 4" (10.2cm) diameter circle. Draw another line around the outside of this line.

2. Draw 4 leaf shapes. Draw a straight line down one third of each leaf. Draw a squiggly line on the larger side of the leaf. Draw another line next to all lines previously made so you have double lines.

3. Embellish both sides of the inside of each leaf. Embellish on the outside of one side of each leaf. Add some teardrops, lines, bubbles and loops. For an added effect, foil the squiggly lines on each of the leaves. Embellish the outer circle as desired.

Double Blessing

CATHERINE M. CALVETTI AND CONNER ERICKSON

3½" × 3½" (8.9cm × 8.9cm)
Strathmore 60-lb. (130gsm) sketch paper, black Sharpie fine-tip pen, black Sharpie fine-point permanent marker

I created this tile with the assistance of my grandson, Conner, when he was five years old.

"There are no mistakes in art. Even a child's scribble is delightful."

—CATHERINE M. CALVETTI

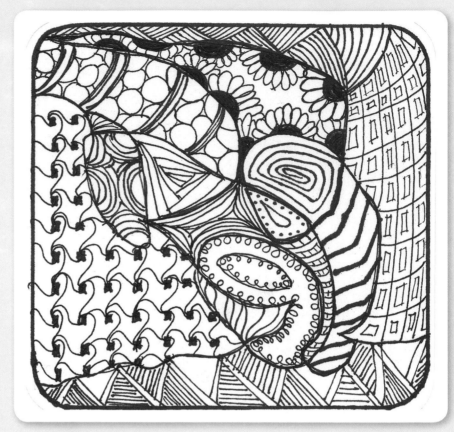

1 Using a stencil, draw a 3½" × 3½" (8.9cm × 8.9cm) tile on your paper. Give your child a pencil and ask him or her to draw some fun lines inside the square. You may need to encourage him or her to add more lines or space them farther apart. Go over the pencil lines with black ink.

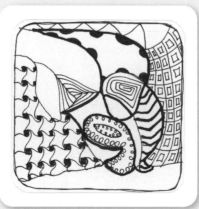

2 Using a grid showing a variety of tangles, have your child pick out one for you to fill in each space.

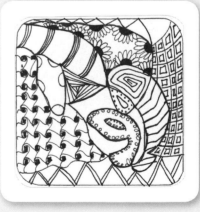

3 Continue adding patterns until the spaces are filled in.

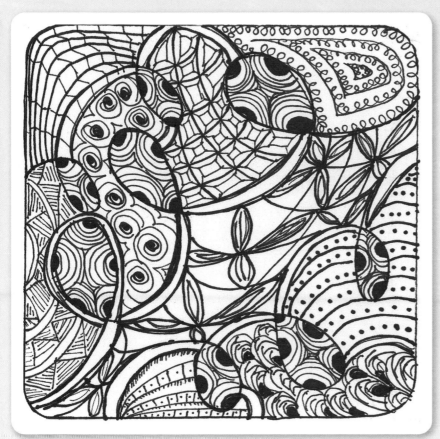

roundabout echo
CATHERINE M. CALVETTI

3½" × 3½" (8.9cm × 8.9cm)
*110-lb. (235gsm) white cardstock,
black Sharpie fine-tip pen*

Since I was a child, I have always enjoyed doodling loopy lines.

"Take time every day to create just for yourself. Don't be concerned with what anyone else thinks."

—CATHERINE M. CALVETTI

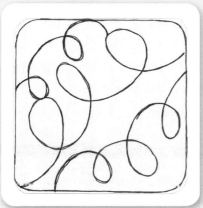

1. Make a 3½" × 3½" (8.9cm × 8.9cm) tile with a stencil. Starting at the bottom left corner, create 3 loopy lines, each in a different direction.

2. Echo the first set of loopy lines. This can be done with the full length of every line or portions of them.

3. Fill the inner loops with a similar pattern. Complete the tile by filling in all the spaces with a variety of patterns.

teamwork

CATHERINE M. CALVETTI AND CONNER ERICKSON

3½" × 3½" (8.9cm × 8.9cm)
Strathmore 60-lb. (130gsm) sketch paper, black Sharpie fine-tip pen, black Sharpie fine-point permanent marker

I created this tile with the assistance of my grandson, Conner, when he was five years old.

"Every child is an artist. The problem is staying an artist when you grow up."
—PABLO PICASSO

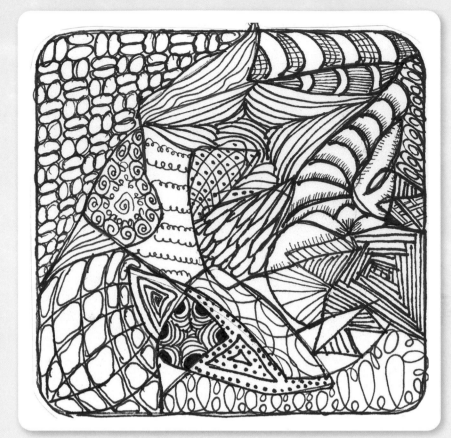

1 Using a stencil, draw a 3½" × 3½" (8.9cm × 8.9cm) tile on your paper. Give a child a pencil and ask him or her to draw some fun lines inside the square. You may need to encourage him or her to add more lines or space them farther apart. Go over the pencil lines with black ink.

2 Using a grid showing a variety of tangles, have your child pick out one for you to fill in each space.

3 Continue until the spaces are filled in with a variety of patterns.

sandworms
VANESSA WIELAND

4" × 4" (10.2cm × 10.2cm)
Felt-tip marker on Blick Mixed Media 80-lb. (119gsm) paper

When I first started this pattern, I was struck by how the circles started to look like eyes peering out from behind fabric. Adding the stripes cut down on the creepy eye effect, but it didn't make it go away completely. It also reminded me of Tim Burton's creations in one of my favorite movies, *Beetlejuice*, and made these patterns even more fun to create.

1 Draw curving lines to create an oval shape in the middle and circles going off the edge on either side. Draw concentric lines around those, and begin developing striped patterns in the first threads created.

2 Continue creating oval forms by drawing curving lines and ovals, similar to wood grain. Add circles in the wider spaces, and draw rings around them.

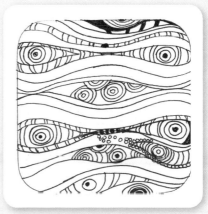

3 Begin drawing stripes that curve out from the circles. Add smaller circles and rings to create an overlap effect within other threads and continue to alternate. Shade in the stripes and concentric rings.

 Complete the patterns in each thread, and in a final few, use small dots to shade.

spool of ribbon

VANESSA WIELAND

4¼" × 4¼" (10.8cm × 10.8cm)
*Felt-tip marker on Blick Mixed Media
80-lb. (119gsm) paper*

As the daughter of a seamstress, I
am quite familiar with the sight of
thread and ribbon spiraling off of a
spool. Ribbon resists containment
and makes organization a nightmare,
but the chaos can be fascinating.
Drawing these ribbons spiraling out
is my attempt to create a pattern, to
wreak order from chaos.

1 Start with a small circle in the
middle. Draw sweeping lines
curving around the circle and
out toward the edges to create
ribbons. Fill in more ribbons
with diverging lines from those
already created.

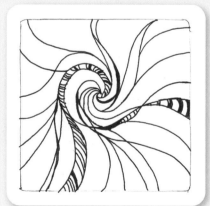

2 Begin defining the ribbons
by drawing stripes of various
widths, curving some of
them slightly.

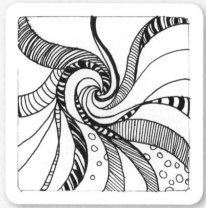

3 Continue to fill in the stripes
and shade them. Then fill in the
background with circles to cre-
ate a bubble effect.
 Complete the stripes so each
ribbon has a different pattern,
creating variety.

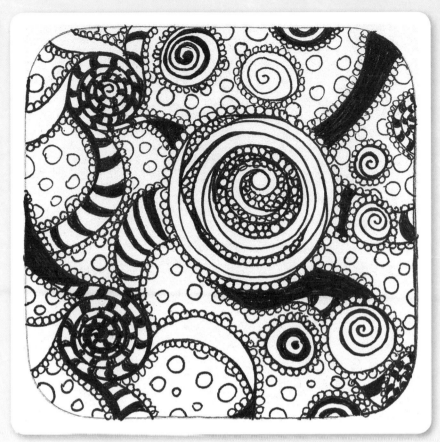

candy land
VANESSA WIELAND

4" × 4" (10.2cm × 10.2cm)
Felt tip marker on Blick Mixed Media 80-lb. (119gsm) paper

Spirals are found in everything from Native American art to primitive cave paintings to contemporary pieces. With no beginning or end, spirals are symbolic of the cyclical nature of time and the changing seasons. Likewise, circles and bubbles have no discernible beginning or end. There's something satisfying about the continuous flow of the pen to paper in creating spirals, and they show up in my art and doodles over and over again.

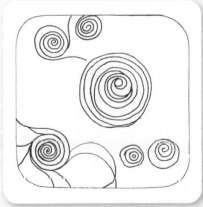

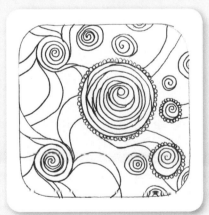

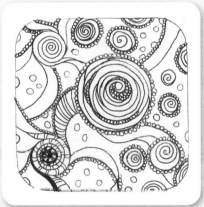

1 Create a closed spiral by overlapping the threads just off center. Add in a few smaller spirals, allowing their ends to trail off into ribbons. Then draw some circles with rings around them.

2 Add more spirals and concentric circles to fill in the composition. Introduce small circles as a border to each spiral and ribbon.

Continue to create ribbons trailing off the spirals. Trail some ribbons behind the others to tie them together.

3 Add stripes to the spirals to give them dimension. Shade in dark stripes, and then add in larger bubbles to create a background.

Color in some ribbons to create contrast on the white background and give the ribbons dimension.

RIBBONS AND RAIN
LYNNITA K. KNOCH

6¾" × 6¾" (17.2cm × 17.2cm)
Pen, ink and graphite on 150-lb. (320gsm) ultra-smooth illustration artist paper

When I created *Ribbons and Rain*, I wanted a design with a border.

"Look for the positive in all situations. perfection isn't all it's cracked up to be!"

—LYNNITA K. KNOCH

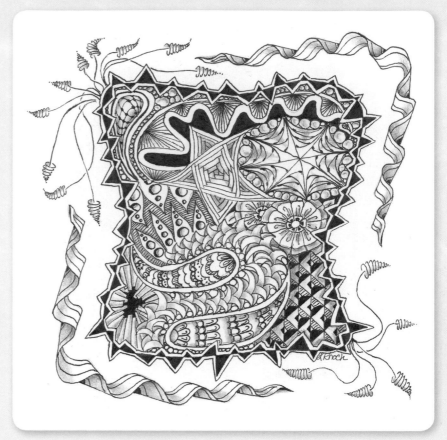

1 I started traditionally, adding a border of similar curved lines and a complex, swirling string. I divided some of the larger sections into smaller sections.

2 *Rain*, a zigzag pattern with an aura, separates the box from the border. *Betweed* forms a star-burst-type pattern with *Pearlz* around the edge in the first section.

3 From the triangular section, I created a 5-sided star with *Auraknot*, using the dividing line below it for a fourth point, and adding a fifth point in the section above. This is a good reason to keep the box and string in pencil.

 Fill in the rest of the string with a variety of other patterns.

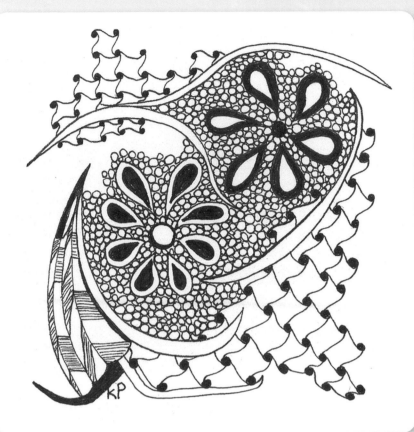

in the Garden
KIM PAY

3½" × 3½" (8.9cm × 8.9cm)
Sakura Pigma Micron Pen black 01 on heavy-weight, artist-grade paper

Relaxing with a doodle can be a way to warm up the creative juices before working on an art project. Sometimes the doodle becomes the project. Nature is full of wonderful shapes, and often while doodling outside in the garden, these shapes and patterns wander into my work.

"Doodling gives the hand permission to create what- ever it wants."

—KIM PAY

1 Make some random marks, lines or shapes anywhere on the paper as a starting point. Your marks can be influenced by your surroundings.

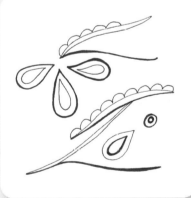

2 Add some repeating shapes or patterns around or beside your starting marks. Thicken some lines by going over them with the pen. Do not try to draw something specific—let the shapes become what they want. Repeat steps 1 and 2 while keeping lots of empty or open space on the paper.

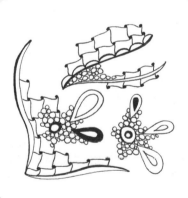

3 Fill in some or all of the open space with repeating patterns that weave around and intersect the doodles you've made. Leave the edges loose and unfinished, or work to a defined border.

pile of Tangles
SUSAN CIRIGLIANO

11½" × 8" (29.2cm × 20.3cm)
*Moleskine watercolor sketchbook,
graphite pencil, Sakura Pigma Micron
pens 01, 02, 05, 08*

Pile of Tangles is from a collection
of drawings called *From Sandy to
Thanksgiving*. While working in this
Moleskine sketchbook, I began to
combine several tile-size images in
one drawing.

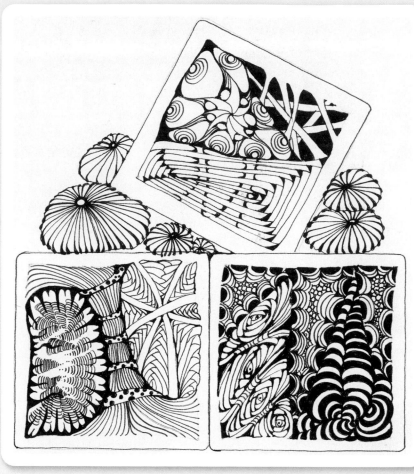

1 Using a 3½" × 3½" (8.9cm × 8.9cm) tile as a template, trace the shape lightly in several places to create an arrangement of tiles.

2 Fill in nooks and crannies with a variation of *Festune* or *Pepper* tangles.

3 Choose a tile to begin. Work on each tile separately. With the pencil, make a dot in each corner, connect the dots to make the border, then add the string. I started this tile with a *Crescent Moon* tangle.

Complete each tile using a variety of patterns that complement each other.

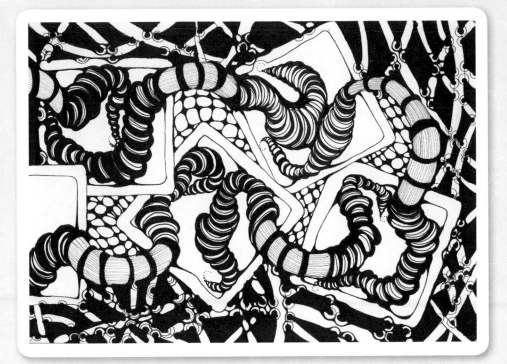

connections
SUSAN CIRIGLIANO

8" × 11½" (20.3cm × 29.2cm)
Moleskine watercolor sketchbook, graphite pencil, Sakura Pigma Micron pens 01, 02, 05, 08

While working in a Moleskine watercolor notebook of Zentangle inspired art, I got an idea that I wanted to make my Zentangle tile shapes connect to one another.

1 Using a 3½" × 3½" (8.9cm × 8.9cm) tile as template, lightly draw an arrangement of tile shapes. Draw a border on each tile but no string.

2 Make curvy, worm-like lines to connect the tiles.

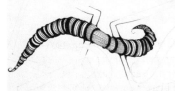

3 Begin tangling the worm shapes first. I used a variation of *Marasu* tangle inside the tile shapes, and *Zander* to connect the tiles.
 When those were completed, I used *Hollibaugh* and *Florz* as a background.

untitled
ELIZABETH SNOWDON

14" × 17" (35.6cm × 43.2cm)
Prismacolor colored pencil and Sharpie marker on 100-lb. (210gsm) vellum surface bristol paper

When I was five, my mother would lay a massive pad of newsprint on the floor, take a marker and swirl a nest of intersecting cells for me to fill in with crayon. I loved the way the colors gave life to the page, how there was no right way for me to color and how even the smallest segments made a difference in the final product. For this piece, I channeled my five-year-old self, but added a grown-up flair with colored pencil.

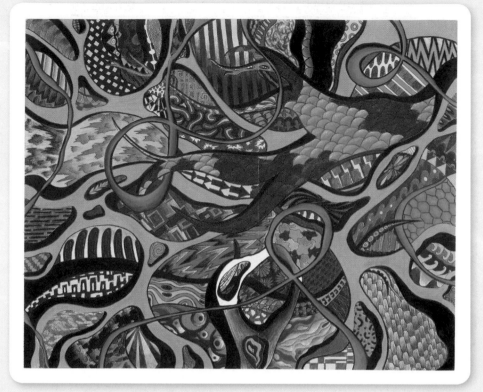

"Don't think, just do."
—ELIZABETH SNOWDON

1 Draw branches and swirls as foreground shapes. Add as many or as few as you like.

2 Fill in the background with free, loose lines. Add black to the edges for depth and contrast.

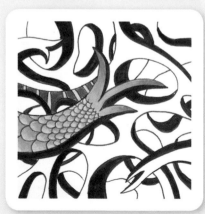

3 Add patterns and color if desired.

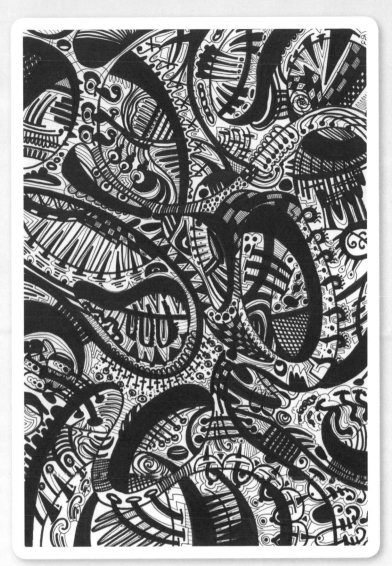

crawl
ELIZABETH SNOWDON

18" × 12" (45.7cm × 30.5cm)
Sharpie marker on heavy-weight textured paper

The partner piece to *Paths* (featured at the beginning of this chapter), *Crawl* sealed my addiction to Zentangles and Zen doodles. The lines came naturally, effortlessly. The more marks I made, the more hypnotized I became by the rhythm of the patterns and the movement of the curves. By letting go of the notion of "making something," I created a work that speaks to my true self.

1 Create a loose background of loops, circles and organic shapes.

2 Make some parts look three-dimensional by adding black along the edge. Keep the black and white balanced throughout the page.

3 Add your favorite patterns. Invent your own. Trace existing lines. Just doodle!

doodle 249
JUNE CRAWFORD

7" × 5" (17.8cm × 12.7cm)

Pitt Artist, Zig Millennium and Sakura Pigma Micron pens on 140-lb. (300gsm) cold-pressed watercolor paper

Over the last few years, my doodles have been heavily influenced by the art of mehndi. Traditionally, the custom of mehndi, using henna to stain designs onto skin, is centered around the concept of awakening the inner light, something I've always found fascinating. You'll find lots of intertwining circles in my doodling with many of the delicate mehndi elements decorating them.

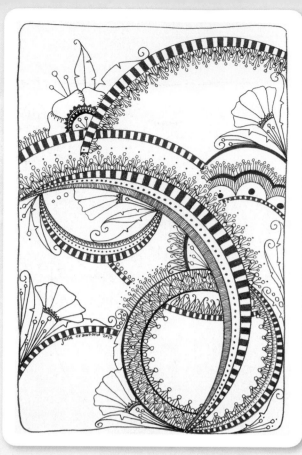

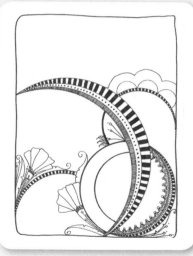

1. Tear down the paper to the desired shape and size. Draw a border around the perimeter of the paper. Create the first off-center circle by using 3 sections—one of black squares separated by white space, another with dots and the third, a line.

2. The first circle acts as the anchor for the piece. From there, build circle upon circle, creating the bold patterns first and adding the fine detail as you travel over the paper. From the first anchor circle, all of the other circles weave around and under or behind it. It creates interest and patterns for the eye to follow.

3. To draw the circles in a variety of sizes, use a compass or circles that are easily found in everyday life—an old CD, a mason jar lid, a coaster. Anything that's round or curved is fair game.

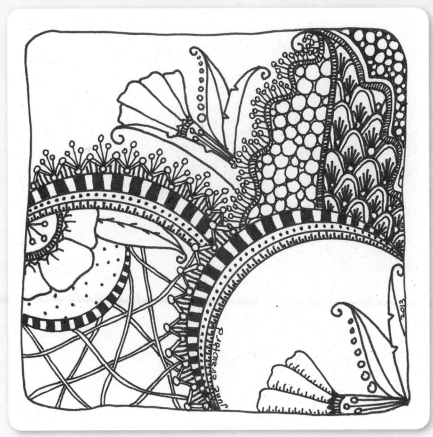

Here are more mehndi-inspired circles with floral and leaf elements.

1 Draw a border around the paper. Draw the first circle on the lower right side.

Add an embellishment on top of the circle. In this case, I drew a stylized leaf.

2 Add more tiny circles above and to the right side of the leaf to fill in the area. Draw a larger circle with three layers to the left of the original circle.

Create floral elements to conform to the outer edge of a circle, in a flat area to fill space or where two circles come together.

3 Add more circles to fill in the left side of the large leaf using single, double or criss-crossing lines to add definition.

Add a final floral design on the leaf to complete the image.

doodle 240
JUNE CRAWFORD

4¼" × 6" (11.4cm × 15.2cm)
Pitt Artist, Zig Millennium and Sakura Pigma Micron pens on 140-lb. (300gsm) cold-pressed watercolor paper, acrylic paints

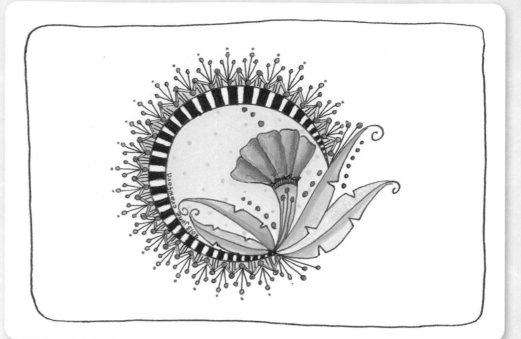

1 Draw 2 leaves on the paper to create the base image for the doodle. Draw a circular line so it appears to come out of the bottom of the leaves.

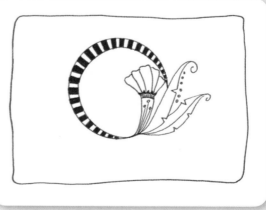

2 Add chunky black squares, and draw a flower into the circle.

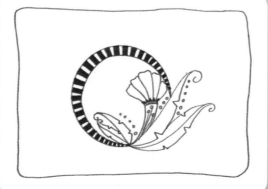

3 Add a couple more leaves and a few tiny circles just for interest. Then decorate the outside of the circle with more lines. Using acrylic paint thinned with water, add color in the desired areas. You could also use watercolor, gouache, markers or colored pencils to add color.

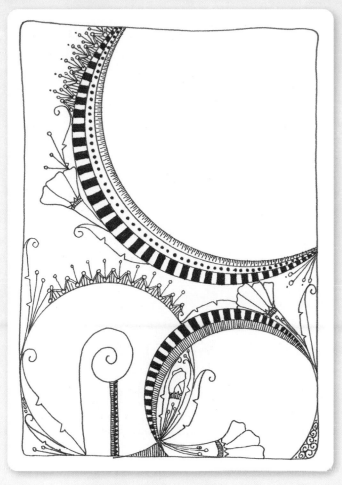

Doodle 251
JUNE CRAWFORD

7" × 5" (17.8cm × 12.7cm)
Pitt Artist, Zig Millennium and Sakura Pigma Micron pens on 140-lb. (300gsm) cold-pressed watercolor paper

I never really begin a doodle with a plan in mind. I like to start with a circle and let the doodle develop as it goes. I don't draw from only one direction, but instead often turn a doodle so I can work on it from several different directions as it progresses. This doodle begins in one direction, but ends up looking better in a totally different one. That happens sometimes.

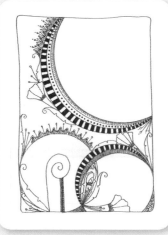

1 Using an old CD, draw in a portion of a circle in the lower left-hand corner. Then draw a couple more circles above and to the right of the original. Add a few elements (lines and spirals) at the top of the page in the blank areas created by the circles to fill up some of the area.

2 Add leaves and a couple of floral elements until you achieve a satisfying balance. The "weight," or the area that contains most of the design, of the circle that I originally thought would be on the lower left feels more appropriate at the upper right at this stage.

3 The space in the large circle is empty and could be used to add a quote to your doodle, if you desire.

heavenly sunshine
KIM REITSMA

7½" × 4¾" (19cm × 12.1cm)
Sakura Pigma Micron markers 01 and 05 in a Strathmore art journal

I have always loved seeing the sun shine through the clouds. The light seems to come in streams or pillars. And when the sun shines through the windows at home, sometimes, if you pause long enough, you can see the dust particles dancing in the air. I was envisioning both of those times as I made this Zen doodle. Keep doodling fun, and use what you enjoy looking at to inspire you, whether flowers or birds or sunshine.

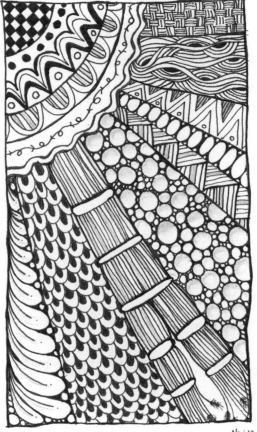

Heavenly Sunshine

Nov 17-18/12

1 Using a fine-point marker or pen, draw a border around your paper. Draw curved lines in the upper left corner with straight lines coming out of the curve to mimic rays of sunlight.

2 Begin filling in some of the rays with a variety of patterns.

3 Continue filling in the patterns, making some lines thicker to hide slight imperfections.
 Color can be added, if desired. I usually add very little color to my doodle, just a highlight here and there.

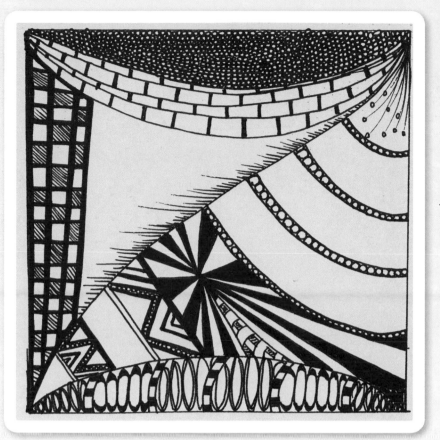

lighthouse Tangle
LEANNE TOUGH

3½" × 3½" (8.9cm × 8.9cm)
Black Bic Triumph 730R Roller Ball Pen (0.5) on Moleskine ivory sketch paper

I started tangling when I was first getting into art journaling. Tangles can make interesting backgrounds for journaling, but sometimes it's just fun to sit and doodle. My tiles, like this one, usually fall into the second category.

1 Start by creating large shapes within your tile, and then splitting it into smaller sections. For this tile, I started by splitting it in half with a wavy line, and then adding extra rounded shapes to the edges.

2 Within these starting shapes, add more lines that segment them. I like to use a mixture of straight and curvy lines for contrast.

3 Finally, work into the shapes you've created. This is where you can start adding little details and creating texture by shading shapes, thickening lines and adding smaller shapes within the segments.

BUNZO
JAY WORLING

5" × 4" (12.5cm × 10.5cm)
A5 sketchbook cartridge paper, black Artline 220 pen 0.2, graphite pencil, Derwent colored pencils

This tile was created in response to "The Diva's Weekly Challenge," which is an online, weekly Zentangle challenge with a set theme. This is a random doodle and has no real string. *Bunzo* is the name of the main black-and-white tangle and is an official Zentangle tangle created by Maria Thomas. I just let this tile do its own thing without any plan in mind.

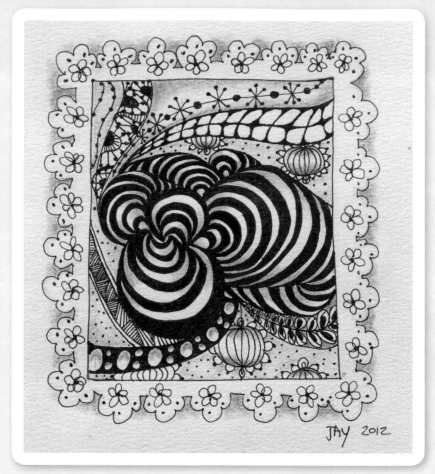

JAY 2012

1 | Start drawing *Bunzo* by creating a curved line and then another behind it until you have a stack of lines. Color in every second line to create stripes.

2 | After you have a significant amount of *Bunzo*, add some streamers that contain some of your favorite patterns. I also drew some *Chinese Lanterns* to add a bit more interest.

3 | To finish, add some random dots across the background, a lace border and then just a hint of color with colored pencils. Add some shading with graphite pencil and a paper stump, if desired.

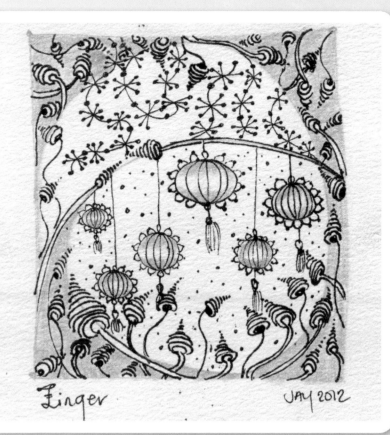

zinger 1
JAY WORLING

2¾" × 3" (7.5cm × 8 cm)
A5 sketchbook cartridge paper, black Artline 220 pen 0.2, graphite pencil

In this "Diva's Weekly Challenge" piece, I moved into a more exclusive Zentangle style where I was using mostly tangles created by other people. There are three tangles in this piece: *Zinger*, *Jax* and my variation of *Bulb Lantern*. *Zinger* reminds me of little mushrooms or toadstools, so I created this tile to have a midnight-garden kind of feel.

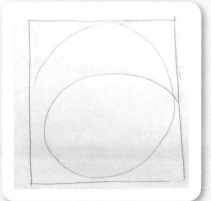

1 This starts with a string that is a simple swirl resembling the @ symbol. Draw this using a pen because it doesn't get erased.

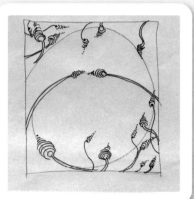

2 Randomly draw *Zingers* around the edge of the tile. Use lots, and don't forget to turn your tile around regularly.

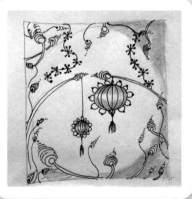

3 Add in some *Chinese Lanterns* and *Jax* streamers, and then shade around the edges, leaving the center white.

zinger 2
JAY WORLING

4" × 3" (10cm × 8cm)
A5 sketchbook cartridge paper, black Artline 220 pen 0.2, graphite pencil

This is the second tile I did for the weekly challenge called "Zinger." This time I wanted to create more of a ground-up feel, as if the zingers/toadstools were emerging from the earth.

This has three official Zentangle patterns in it: *Zinger*, *Bunzo* and *Socc*.

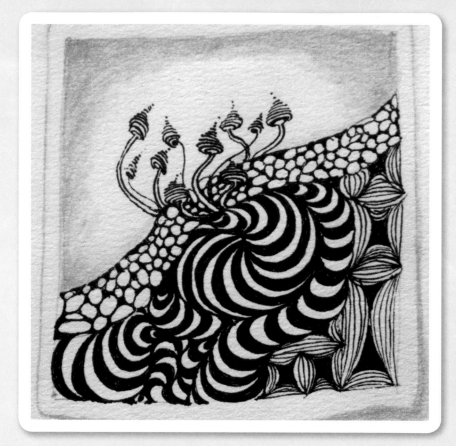

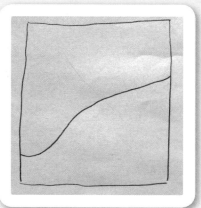

1 | Draw a simple curved line across your tile or page.

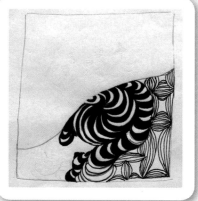

2 | Fill in the bottom half with *Bunzo* and *Socc*. Fill in any spaces with black pen.

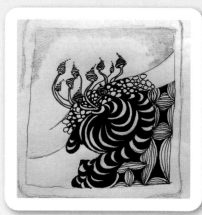

3 | Next add the *Zingers* so they look as though they are growing out of the *Bunzo*. I added a line of river rocks, which are circles crowded together with the spaces in between filled in with black pen. Finish off with some shading for added dimension.

Sign up for our free newsletter at CreateMixedMedia.com.

Aloha Doodle
MOLLY ALEXANDER

8" × 8" (20.3cm × 20.3cm)
Sakura Pigma Micron Gel and Glaze pens, acrylic paint, crackle glaze, clear matte spray paint, scrapbooking paper, matte decoupage medium

I fell in love with these flowers from a piece of scrapbook paper, and I wanted to incorporate them somehow into a mixed-media piece. I didn't actually name this piece until it was finished. When it was complete, it reminded me of the hibiscus plants I saw on my honeymoon in Maui, Hawaii.

1 Paint the background with acrylic paints partially covered by crackle medium. Allow the crackle medium to dry, then use watered-down black acrylic paint to bring out the cracks in the finish. Seal the paint with clear matte spray paint.

After the background is sealed, decoupage the main design elements onto the piece using a matte decoupage medium.

2 Using a black gel pen, outline the decoupaged flowers, and add a second line just inside the border of the flowers, trying to keep the line spacing as consistent as possible.

3 Using a white gel pen, add 3 layers of outlines around the outer border of each flower, trying to keep the line spacing as consistent as possible. Continue to use the black and white gel pens to decorate the inside of the flowers and the border of the canvas until they are full of doodled elements. Add color using glaze pens as desired.

Doodle Two
(Circle Patterns)
G. BLAINE LIDDICK III

14" × 11" (35.6cm × 27.8cm)
Faber Castell Pitt Artist Pens on Borden & Riley #234 Paris Paper for Pens

This was created as one of the first projects for my art class, "Intricate Doodles at the Doris" (Community Cultural Center). My inspiration for the designs came from my teacher, fellow students and online research of design patterns. You can find this braided pattern in the center of the two large circles.

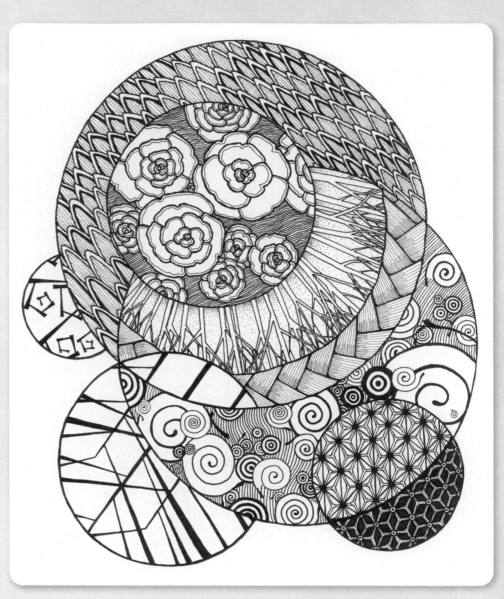

1 | Draw two parallel lines and then a zigzag pattern down the middle between them. Do not connect the zigzag to either line.

2 | Extend the lines of the zigzag to the outer edge lines, creating a braided effect.

3 | Darken the lines, round off the outer edges and inner corners, then draw in shading or "reed lines" if you wish. This pattern can also be done on a curve, as shown in the center of the completed image.

Sign up for our free newsletter at CreateMixedMedia.com.

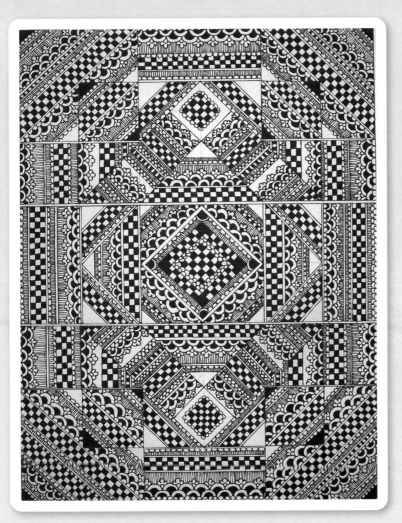

mehndi
BETSY JONES

6" × 4" (15.2cm × 10.2cm)
Sharpie Ultra-Fine Point marker on Strathmore 400 series paper

My inspiration came fifteen years ago when I was introduced to henna tattoos and mehndi art, and immediately fell in love with these delicate yet bold patterns of the Middle East. I've been doodling in this style ever since!

"Always stay true to yourself, your art and your vision; the rest will fall into place!"
—BETSY JONES

1 Block off your main sections, and pick your starting point. Start adding your shapes and patterns in your first section.

2 Before you get too far with section one (so you don't get lost), start working radially, adding your pattern to the next sections in the same manner as the first.

3 Keep adding curls, checkerboards, lines and shapes until all sections are complete. Then go back and clean up your edges and colored areas.

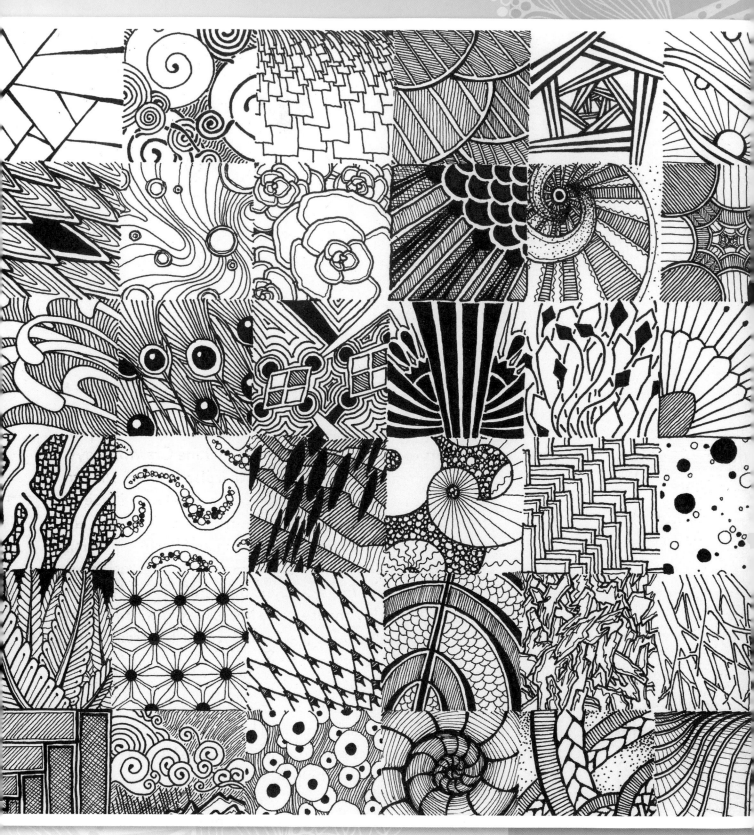

doodle one (quilt pattern)
G. BLAINE LIDDICK III

shapes & objects

Sometimes beginning a Zen doodle masterpiece can seem daunting. Once we've started, it's easy to get into the flow and relax, but how or with what direction do we actually start?

This is where basic (or not-too-basic), familiar shapes, objects or forms come in handy. As June Crawford says, "I never really begin a doodle with a plan in mind. I like to start with a circle and let the doodle develop as it goes."

By giving ourselves the confines of a shape, we often find it much easier to dive in and begin repeating patterns when we have a line to cling to. Letterforms, stars and plant life are all examples of familiar shapes you'll see in this chapter, and it's easy to see how any of these could easily inspire us to get past the trepidation and just get started already!

As June mentioned, the circle is one of the most common shapes used in Zen doodling. One version of that, the "Zendala"—inspired by the ancient form of the Mandala—offers a slightly more structured approach for those who find that helpful.

Regardless of your favorite form, we can't wait for you to try out some of the patterns in this chapter and see what takes shape in your own Zen doodle art.

zendala–Leaves & Fish

DEBORAH A. PACÉ

3½" × 3½" (8.9cm × 8.9cm)
Bristol smooth vellum paper, Sakura Pigma Micron pens 005, 01, 08

Sometimes when I create a Zendala, I don't know where to start. By placing an X or cross in the center, I then have something to work with other than a blank tile. Zendalas are typically worked from center out, but I don't always know what I want to start with, so I will mark the center and then work from the outside in.

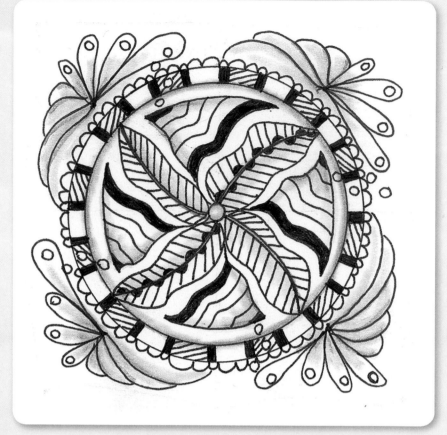

1 Draw 2 lines with a pencil from each corner of the tile. Draw a small center circle, and with a compass draw a 2" (5.1cm) diameter circle and then a 2½" (6.4cm) diameter circle. Erase the pencil lines after going over the circles with a pen.

2 Add a design in the center and then at each corner of the tile.

3 Embellish your design and add shading as desired.

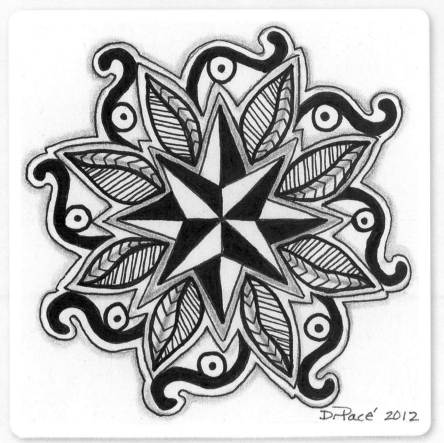

mariner's star
DEBORAH A. PACÉ

3½" × 3½" (8.9cm × 8.9cm)
Bristol smooth vellum paper, Sakura Pigma Micron pens 005, 01, 08

I started with a *Mariner's Star* pattern in the center. After that, I didn't know what I was going to do next. I read or heard somewhere that if you don't know what to do next, draw a line around it, and that is what I did. After that, the design started emerging, and after each pattern, I drew a line around it.

1 With a pencil, draw a cross and an X on the tile. Now draw an eight-pointed star in the center with a pen. Divide the star into segments. Erase the pencil lines.

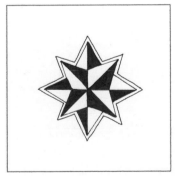

2 Color in every other segment in the center and outer star. Draw an outline around the entire image.

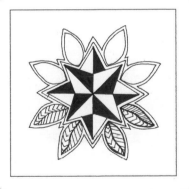

3 Continue adding to the design, and draw a line around the design before adding your next pattern.

Hugg-N
NANCY V. REVELLE

3½" × 3½" (8.9cm × 8.9cm)
Zentangle® tile, black Sakura Pigma Micron Pen 01, graphite pencil

I set out to do two initial tiles, this one with an "N," to experiment with intentionally shaped, recognizable strings. I knew I wanted the woven look of *Huggins* (hence the tile's name). Some formal structure with *Archer* filled the lower triangle, and *Flux* grows out of the upper triangle. To finish it off, I added a short run of *Zander* on the lower right, some *Mooka* for flourish and *Tipple* as a border.

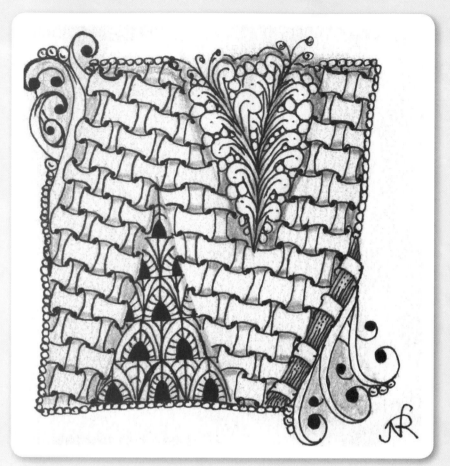

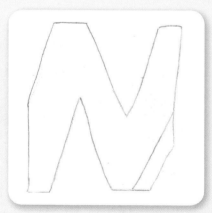

| Draw your letter in pencil.

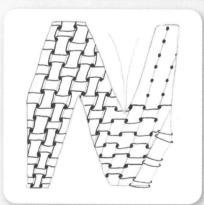

2 Lay out *Huggins* inside the letter with parallel pencil lines and large ink dots (you can use a thicker pen for these). Begin to weave the pattern by connecting the dots in an over/under manner as shown. (This can be tricky until you get the hang of it.)

3 *Archer* is begun in the lower triangle of the letter with horizontal and vertical grid that is filled with gently curving sections of "windows" as in the diagram. Add other patterns as desired and shade with a pencil and tortillon.

woven L
NANCY V. REVELLE

3½" × 3½" (8.9cm × 8.9cm)
Zentangle® tile, black Sakura Pigma Micron pens 01 and 05, graphite pencil

In this second initial tile, I drew a loosely curving "L" and filled it with the woven look of *Bilt*. I kept it simple with this tile, filling fairly large areas with the peacock-eyed *Pavonia*, some graceful *Flux* and a variation of *Onomato*.

1 Lay out the letter with pencil in two segments with the lower flowing like a flag in the wind, and create border areas. Line the letter in pen with double lines, and start the weave by drawing "V" shapes, working down and inside the letter.

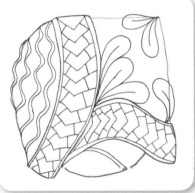

2 Add lines from the center point of each side of the "V" to the border or to the previous "V" to make a brick-like pattern. The left side is filled with *Pavonia*, which is a series of double wavy lines that create oval spaces for the "eyes."

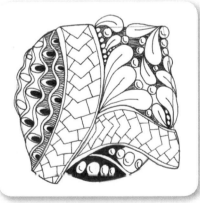

3 Add the eyes as shown, and fill the spaces to the sides of the eyes with curved ripples like parentheses. Add other patterns in the remaining sections.
 Erase any string lines that show, and shade with a pencil and tortillon.

arabian-style Tangle
NEIL BURLEY

3½" × 3½" (8.9cm × 8.9cm)
Black Uni Pin Fineliner 03, 2B pencil on 135gsm cartridge paper

I first came across the concept of Zen doodling at the beginning of 2011, and since then I have been tangling and designing patterns in between my other creative pursuits. This tile developed from work I have been doing at college looking at Islamic geometric patterns. I created the outline as a line drawing first, before transferring it to the tile. The fill-in patterns are all based on my own designs, inspired by the patterns I see around me. Adding the pencil shading really helps the tangle dip in and out of the page.

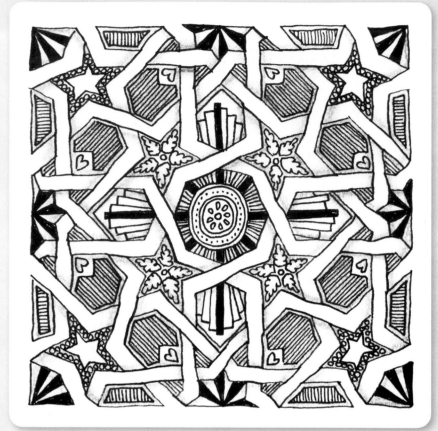

1 Trace the pattern onto the tile. Create the tangle by drawing lines across the intersections, alternating direction at the next junction (bottom right).

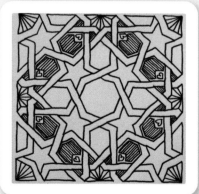

2 Fill in the sections with patterns of your choice. I like making some with directional lines to draw the eye around the tile.

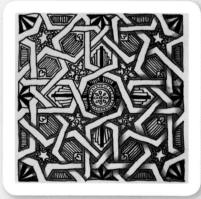

3 Add shading with a 2B pencil, following the tangled border, taking note of the overs and unders. Blend with a paper stump. Tidy up with a fine eraser.

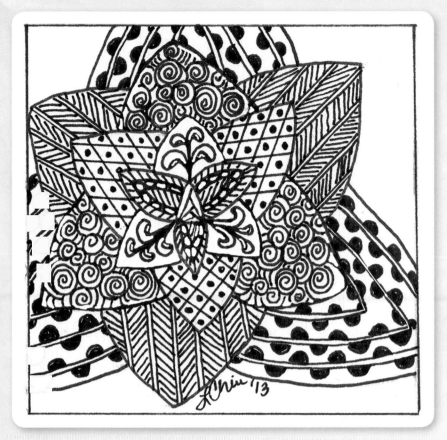

zenFlower

LISA CHIN

3" × 3" (7.6cm × 7.6cm)
65-lb. (140gsm) fine-texture paper,
Sharpie pen

I enjoy the symmetry of flowers and wanted to create a piece using this as my inspiration.

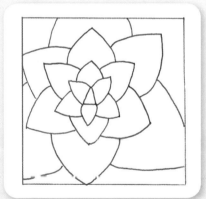

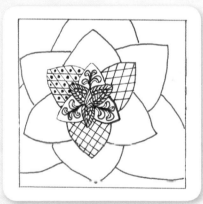

1 The center of a flower is typically small, with the petals growing larger toward the outside. Begin your *ZenFlower* with a small triangle just off center inside the square. The first 3 petals are drawn on each side of the triangle.

2 The second row of petals is created by drawing a slightly larger petal in between each of the first 3 petals. Continue to create rows of 3 petals around the flower, with each row getting a little larger.

3 Play with filling every petal with a different doodle, or create symmetry by filling each row of petals with the same doodle.

in and out
MING-WHE LIOU

3" × 3" (7.6cm × 7.6cm)
Extra-fine and medium-size black markers on regular printer paper

Years ago I made a tapestry design of layered circles and squares to express overlapped visual transformation. *In and Out* sprouted from a similar idea.

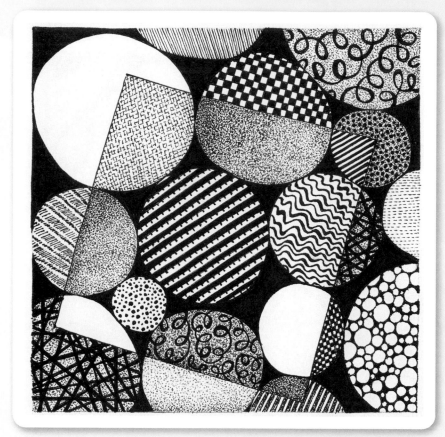

1 On the center of a 3" (7.6cm) tile, draw a smaller skewed square.

2 Then draw different sizes of circles, both in and around the box. Create tension by arranging the circles close to each other. Use a black marker to cover up portions of the background.

3 Doodle a variety of lines, dots and checkered patterns on the circles in the inner and outer box. A solid black background together with white and stippled gray tones makes the straight and curved surface full of strong contrast and playfulness.

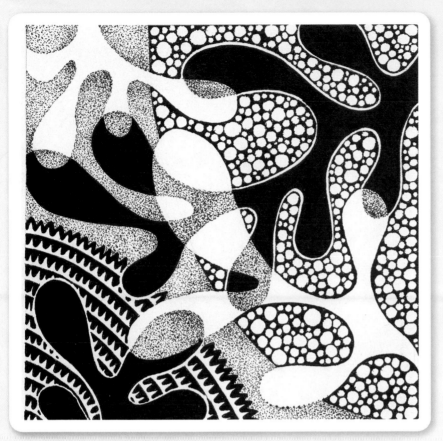

seaweeds
MING-WHE LIOU

3" × 3" (7.6cm × 7.6cm)
Extra-fine and medium-size black markers on regular printer paper

Some of my artworks are inspired by nature. This particular design is related to the free movement of floating seaweed and coral reefs beneath the ocean, but in an abstract manner.

1 Begin your tile with dotted outlines of 2 blank branches on opposite corners.

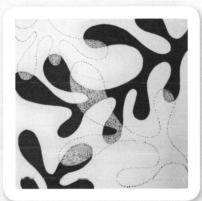

2 Add a second pair of branches of different sizes. Color both branches using black, and add tiny dots in the overlapping areas to form gray.

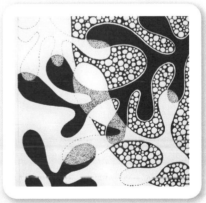

3 Draw 2 quarter circles in opposite corners, covering the big one with a polka dot pattern and the small one with a zigzag pattern. Finally, stipple the background and branches with more dots to make uneven shading.

odd Gatherings on a Hillside
LESLIERAHYE

4" × 4" (10.2cm × 10.2cm)
Staedtler Pigment Liners .8mm, .5mm, .3mm, .1mm on 25 percent cotton, 130-lb. (275gsm) Pentalic heavy-weight natural white drawing paper

I have always doodled, but I began creating Zen doodles about two years ago when crafty friends introduced me to the art. I can relax and release stress while producing little tangled patterns on a small card—it's my happy place, just like meditation.

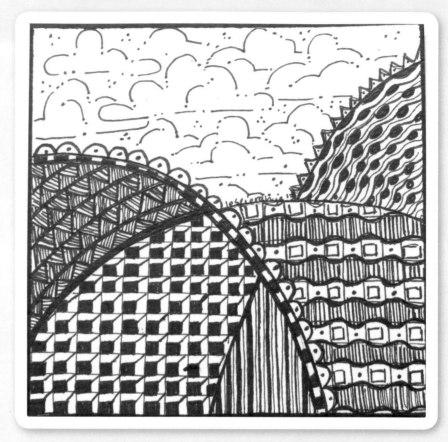

1 To create the pattern in the lower right corner, begin by making a grid pattern of horizontal and vertical lines with a thin-tipped pen.

2 Next, alternate "happy smiles" and "sad smiles" within the grid pattern. When connected, the smiles make a gentle, rhythmic curve.

3 With a medium-fine tipped pen, create lines vertical to the curve all the way across. Skip every other row. Finally, fill in the remaining rows with dots in the boxes that have smile curves inside, and add small squares in the open boxes.

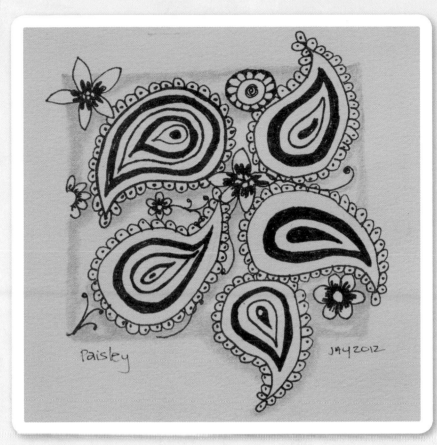

paisley
JAY WORLING

4½" × 4½" (11.5cm × 11.5cm)
A5 sketchbook cartridge paper,
black Artline 220 pen 0.2,
graphite pencil

This piece was inspired by a trip to a hardware store. While my partner was looking for tools, I looked at wallpaper. I ended up coming home with a large stack of wallpaper samples.

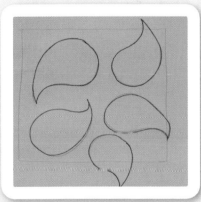

1 Draw teardrop shapes around your page or tile. Use pencil and then go over them with a pen. Don't forget to turn your picture around as you work on it; it's much easier than trying to draw upside down.

2 Fill the insides of the teardrop shapes with lines that follow the outer shape. Randomly make them thick and thin. Draw scalloped edges around the outside.

3 Add some flowers or other shapes into the tile. Start to shade around your tile with a pencil. If you have a tortillon or paper stump, you can use this to create even shading. Build your shading up: pencil, smudge, pencil, etc., so you get depth in your shading.

pinwheel
JAY WORLING

4¾" × 5" (12.5cm × 13cm)
A5 sketchbook cartridge paper, black
Artline 220 pen 0.2, graphite pencil

Pinwheel was a response to "The
Diva's Weekly Challenge," which was
titled "Pinwheels for Peace." The
hardest part of this tangle is drawing
the pinwheel. There is a template,
but I've never been much into those,
so here is how I tackled it.

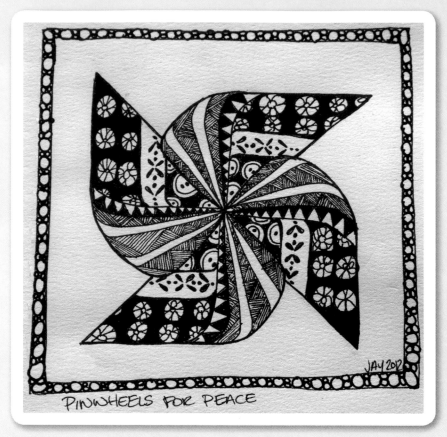

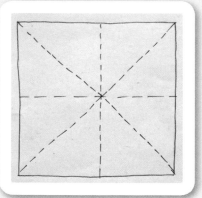

1 Using a pencil, draw a square on
the tile. Then draw a line down
the middle from top to bottom,
then another from left to right.
Finally, draw 2 diagonal lines,
one from each corner.

2 Starting at the center of the
square, draw up the diagonal
line to the top corner. Draw left
along the top line to just before
the center, where you will create
a curve to follow the middle line
back to the center of the square
(follow the red arrows). Starting
at the top of the curve you just
made, draw left again along the
top line, and create another
curve down to the diagonal line.
Follow that line back to the
center (green arrows). Repeat in
the other 3 sections.

3 Now with your trusty pen, draw
back over the lines you have just
created. Rub out all the pencil
lines to reveal the pinwheel.
 Add doodles in each section
and a border around the edge.

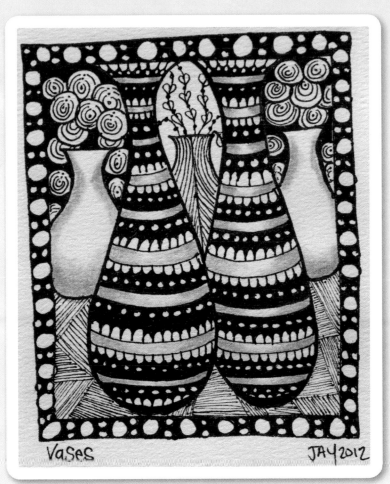

vases
JAY WORLING

4½" × 3½" (11.5cm × 9cm)
A5 sketchbook cartridge paper, black Artline 220 pen 0.2, graphite pencil

Vases started with a squiggle that looked like a pair of tonsils. After turning it around a few times and staring at it in a squinty kind of way, some vase shapes appeared.

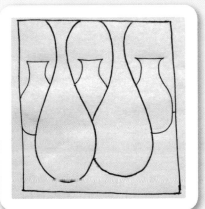

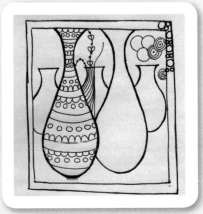

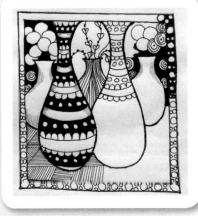

1 Draw in some vase shapes using a pencil. If there is a gap between the vases and the border, put in a line to indicate the floor space. Go over the lines with a black pen.

2 Make the lines around the vases a bit thicker, and add in the outer border. Start drawing in the details and patterns.

3 When the patterns are completed, fill in all the background areas you want to be black. Use cross-hatching to create the flooring. Then switch back to pencil and add in some shading to create a bit of 3-D pop.

Ladybug's Leaf
KRISTEN WATTS

5½" × 5½" (14cm × 14cm)
Black Sakura Pigma Micron Pen on white drawing paper

Ladybug's Leaf began with a curvy scribble and continued to evolve as I added patterns to fill the space. At first, only the leaf jumped out at me, but as I neared the end of my doodling, I thought the paisley doodle, combined with the pattern below it, formed a circular shape and looked kind of like a ladybug. I added the black head with eyes as a final embellishment. Can you find the ladybug?

"Art is not what you see, but what you make others see."

—EDGAR DEGAS

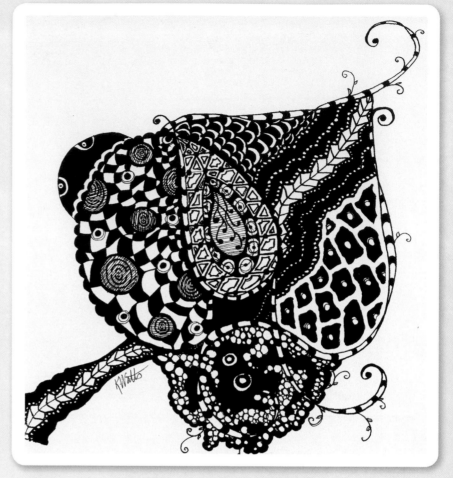

1 Start your Zen doodle with a continuous line that looks similar to the shape of a leaf, or use this line to get you started.

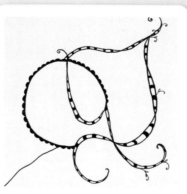

2 Define the shape by adding patterns and embellishments to the original line. At this step, you can also add additional lines to make your shape even more recognizable. Here I added a new line to work the leaf stem into the picture.

3 Continue by dividing up your empty spaces with different patterns. You can overlap and layer patterns, fill in around your patterns with black or leave the space around your patterns white. I try for contrast that is pleasing to the eye.

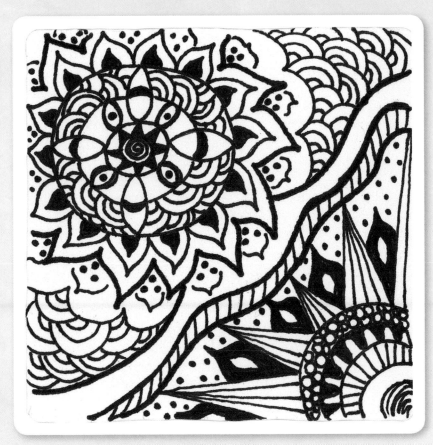

flowers 2
ANNE GRATTON

3½" × 3½" (8.9cm × 8.9cm)
Zentangle® tile, black Ultrafine/Fine twin-tip Sharpie permanent marker

I got into Zen doodling two years ago. The art form is very fun and playful. What I love about it is there is no right or wrong way to design a doodle. I can sit and watch TV and doodle. I can be relaxed and creative at the same time!

"Have fun, relax and enjoy the creative process!"
—ANNE GRATTON

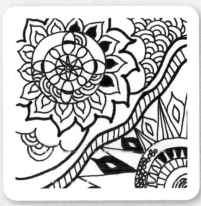

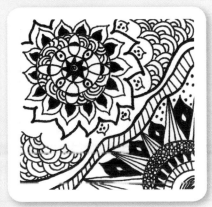

1 Start by drawing a pair of wavy diagonal lines across the Zentangle® tile using an extra-fine marker. It breaks up the space nicely. Then fill in the basic flower shapes. While drawing, don't forget to rotate the tile to keep the petals looking uniform.

2 Once the petals are drawn, use a thicker marker to make some of the lines bold. Different line widths look better. Start filling in some of the spaces with various patterns, leaving some areas white.

3 Try to use the same pattern in a couple of the areas to keep the tile symmetrical and cohesive. Look at the tile. If some of the areas blend in, carefully redraw some of the lines with the thicker marker to make them bolder.

c is for catherine

CATHERINE LANGSDORF

4¼" × 4¼" (10.8cm × 10.8cm)
Sakura Pigma Micron pens 01, 005 on Canson bristol paper

This tile was created for an online challenge asking participants to use just three different line patterns. As a calligrapher, I am fascinated by letters, so I decided to start this image with the letter "C." I find the act of creating these line images to be a great warm-up before crafting letters and flourishing my calligraphy. This piece was inspired by the Zentangle® method of pattern drawing.

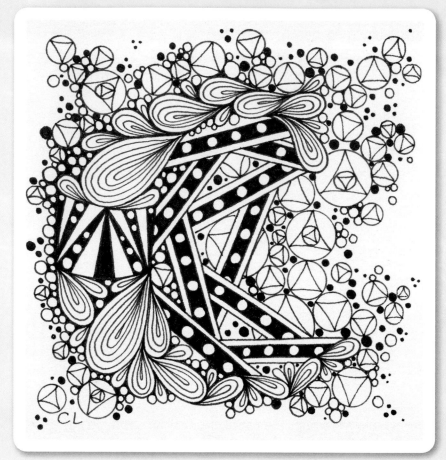

1 Draw a letter in pencil first, and then begin decorating the letter in 01 Micron pen by adding a band of triangles at the center of the letter. Next add paisley shapes to complete the basic letter.

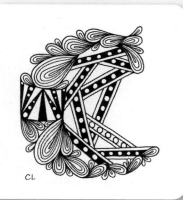

2 Switch to the 005 Micron pen and fill in each paisley with smaller and smaller paisleys. Then add the pattern of straight lines and circles.

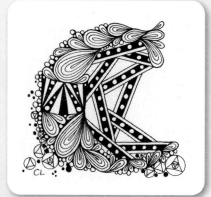

3 Continuing with the 005 Micron pen, add various sized circles to fill up the tile.
Inside some of the larger circles, draw a triangle. To help balance the black lines, add some small black dots.

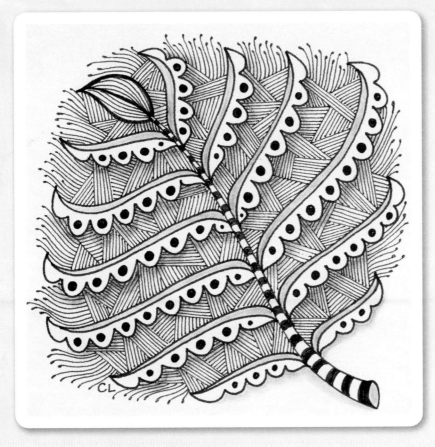

blue Highlighted Leaf
CATHERINE LANGSDORF

4¼" × 4¼" (10.8cm × 10.8cm)
Sakura Pigma Micron pens 01, 005,
soft pencil on Canson bristol paper,
blue colored pencil

Nature provides many patterns and images for artists. I enjoy creating art that has a recognizable image and creative touches to delight the viewer. This piece was inspired by the Zentangle® method of pattern drawing.

"I have been drawn to this type of artwork because it obstructs the inner critic and allows me to simply draw, discover my potential and enjoy unexpected results."

—CATHERINE LANGSDORF

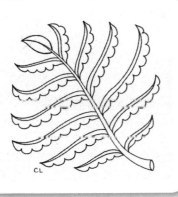

1 Using a 01 Micron pen, draw the basic veins of a leaf, and then add the scallop trim on each vein.

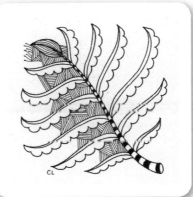

2 Switch to the 005 Micron pen for adding the line details between each scalloped vein. Add the black squares to the center vein.

3 Draw a dot in each scallop to add more interest to the leaf. Next use a sharp colored pencil to give a small pop of color to each vein.

A touch of shading will give more depth to the tile.

mail
JANA BODIN

3½" × 3½" (8.9cm × 8.9cm)
*Pencil and Faber-Castell Pitt artist
pen on Strathmore artist paper*

I designed *Mail* while working on
a mail art project. I was working
with prompts from the webpage
of Daisy Yellow for inspiration.
Because one of the prompts I
used was "Mail," and I associate
mail with a letter or envelope, this
tangle just happened naturally.

*"Don't wait for the
right time to start
doing what you
love. Do it now!"*
—JANA BODIN

1 Draw evenly spaced lines diago-
nally across the tile—preferably
an odd number of lines.

2 Pick an area on your tile that
you would like to become the
guide envelope. Connect 2
of the diagonals with lines at
a 90-degree angle to shape a
rectangle. Fill this rectangle
with the typical flap and seam
lines of an envelope.

3 Use your guide envelope to
extend the outer lines of the
mail to the edge of the tile.
These lines should be perpen-
dicular to the lines drawn in
step 1. Continue to draw evenly
spaced parallel lines across the
tile. Mirror the guide envelope
in the spaces between the per-
pendicular lines. Continue with
this pattern until all rectangular
spaces are filled. Color or shade
a single mail or all of them.

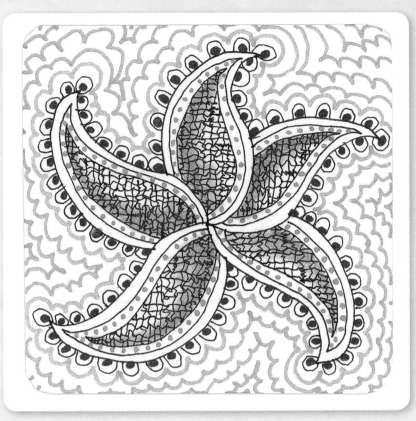

fengle variation
JANE REITER

3½" × 3½" (8.9cm × 8.9cm)
Pen on 300-lb. (640gsm) watercolor paper, black Sakura Pigma Micron pen 01, Sakura Gelly Roll black sparkle, Sanford Uni-Ball Gel Impact 1.0 mm gold, 2B graphite drawing pencil

This drawing uses Zentangle's® *Fengle*, as a starting point. I started tangling in 2012 and participated in the tenth Certified Zentangle Teacher training seminar, which greatly enriched my life! Zentangle gives me a creative outlet that encourages quiet personal reflection and gentle instruction of students.

1 First, draw 5-spoked *Fengle* using an "S" curve line and Micron pen.

2 Connect each "S" curve to the previous "S" curve to create five petals.

3 Draw 2 interior lines within each spoke. Fill each interior with the *Cheesecloth* tangle and shade with a pencil.

Create a border of dots with a Gelly Roll pen around the entire shape. Draw an aura line with a Micron pen around each dot.

Draw auras around the entire *Fengle* star to the edges of the tile to complete.

my metamorphosis
CHRISTINE ALANE FARMER

8½" × 11" (21.6cm × 27.9cm)

*Mead Academie wire bound sketch diary, Sharpie No-Bleed Fine-Point Pen,
number 2 pencil, Loew-Cornell blending stump*

I love to spend time in my studio making jewelry, soldering, weaving or
making collages or art dolls. I have Meniere's disease, and one of the
symptoms is varying degrees of vertigo. Some days I find myself stuck in bed,
but I am still able create art by Zentangling. Zentangling allows me to keep
still to help slow the spins of vertigo, and getting lost in the process helps
pass the time. *My Metamorphosis* was inspired by my desire to change and
become a braver, stronger girl who must be flexible and able to constantly
and quickly adapt to the changes in my world with the Meniere's disease.

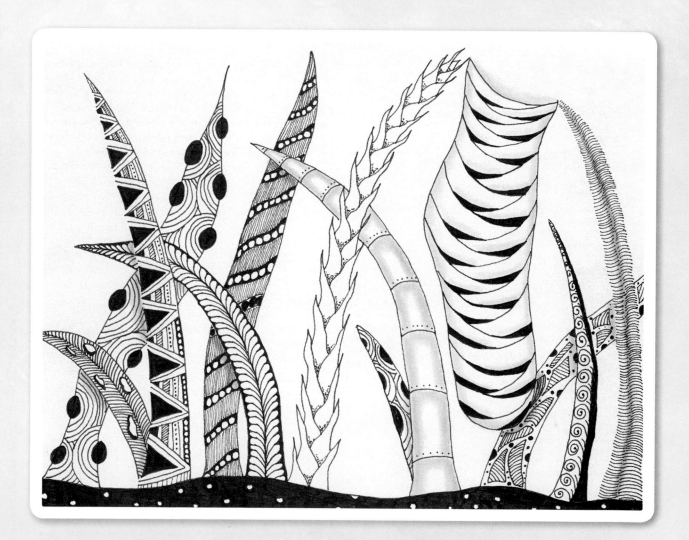

1 Draw outlines of blades of grass using a pencil so you can go back later and choose which blades will go under and which will go over. Then trace some, but not all of the blades of grass in pen. Allow the designs and patterns to show you the border of the elements. Leave the center blade penciled in to serve as a guide in the next step. Begin to add designs in some of the blades.

I have chosen to add an outline for a cocoon hanging between two grass blades.

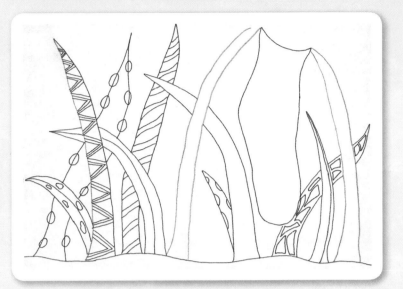

2 Continue filling in the blades with a variety of designs. I added holes to the second blade from the left and thorns to the center blade, using the pencil line as a guide. The blade to the left of the cocoon has been drawn to look like riveted metal and will be shaded in pencil to give it a rounded, shiny appearance.

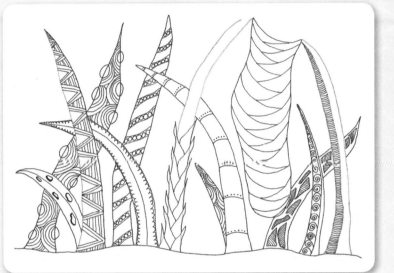

3 Finish adding designs to each of the blades, and color in selected areas with black ink.

Finally, add shading to the piece. This takes the tangle from flat to three-dimensional. Be sure to shade under the leaves that are over others to make the blades pop.

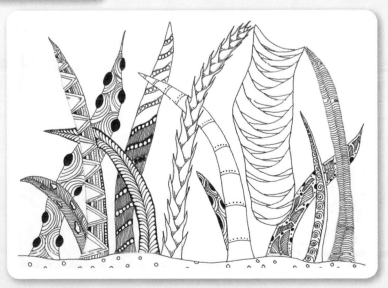

Doodle one
(Quilt Pattern)
G. BLAINE LIDDICK III

11" × 14" (27.9cm × 35.6cm)
Faber Castell Pitt Artist Pens on Borden & Riley #234 Paris Paper for Pens

This was created as one of the first pieces for my art class, "Intricate Doodles at the Doris" (Community Cultural Center). My inspiration for the designs came from my teacher, fellow students and online research into design patterns. You can find the "Trees in a Forest" design in the lower right area.

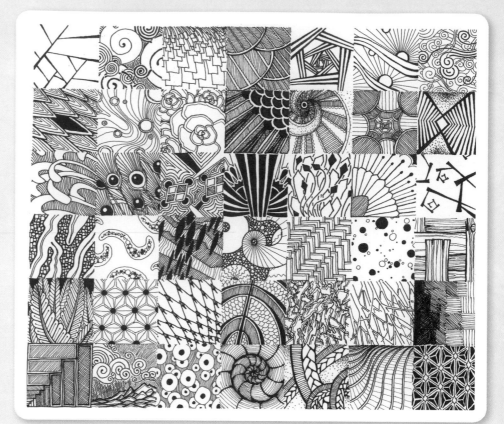

1 Draw one set of parallel lines for the top and the bottom of the trees. Choose the distance apart based on how tall you want your trees to be.

2 Just like a tree grows from the ground up, start each tree that way. You might find it easier if you flip the paper upside down and start with the base of the tree and draw "downward" to the branches. Run branches at about 30-degree angles and always alternating from one side to the other.

3 Duplicate the process until you have 3 or 4 trees out front, then simply place other trees behind the initial ones. Keep going until your forest is completed to your satisfaction. Stippling between the trees helps to provide a background.

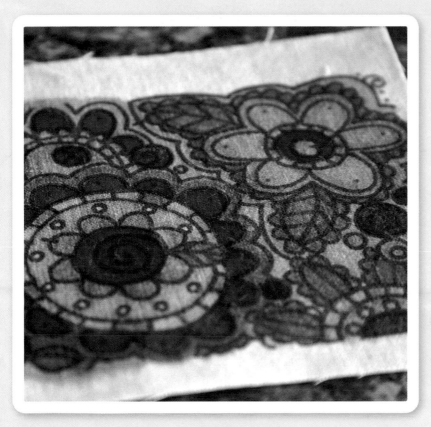

scrapple doodle
STEPHANIE ACKERMAN

3" × 5" (7.6cm × 12.7cm)
Sharpie marker on Strathmore, smooth bristol paper, canvas or muslin fabric, Prismacolor Premiere markers

During my first teaching trip to Pennsylvania, I learned the term "scrapple." It is something you eat and is a "whole bunch of things" smashed together to make one thing, sort of. I will never try it, but the word "scrapple" reminds me of the way I am doodling these days—many things squished together. I gave the name "scrapple doodle" to my style of work.

"create a life that reflects your dreams. Live a life that defines your purpose."

—STEPHANIE ACKERMAN

1 | On a 3" × 5" (7.6cm × 12.7cm) piece of muslin, canvas or paper, draw a circle. Draw a pair of circles around the first one. Add a few petals, a leaf on the side and a few details like pinpoint dots on the ends of each petal.

2 | Add an outline around the entire flower and leaf. Add small scallops around the entire outline, and then finish with a final outline.
 Repeat steps 1 and 2 in another area of your substrate.

3 | Continue each step until you have filled in your area. Create a border around the outside edges. Fill in all remaining spots with leaves, circles and scallops.
 Add random designs around the entire space to keep the design balanced.

winter tree
CATHERINE M. CALVETTI

3½" × 3½" (8.9cm × 8.9cm)
Strathmore 60-lb. (130gsm) sketch paper, black fine-tipped Sharpie Pen

I created this tile while sitting in the vehicle waiting for my husband. I was captivated at the shape of a tree in the middle of winter and used the silhouette to inspire me.

"inspiration is everywhere. keep looking at everything around you."

—CATHERINE M. CALVETTI

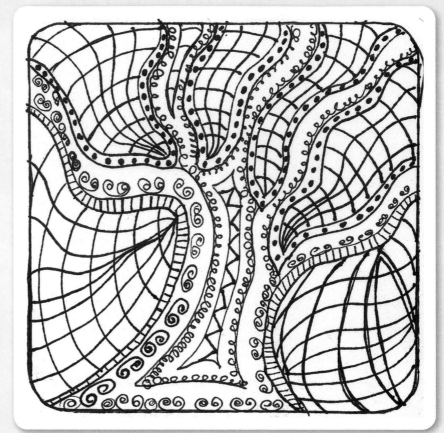

1 Draw a 3½" × 3½" (8.9cm × 8.9cm) tile using a cardboard stencil on paper. Create an outline of a tree silhouette for your string.

2 Draw lines on the inside of the silhouette following the curve of the trunk and branches. Fill in that space with lines and dots.

3 Draw the inner trunk, filling it in with your favorite pattern. Make a small, looping flourish along the trunk line and up the branches. Be sure to turn your tile as you go. Fill in the white space in the background with an evenly spaced open tangle.

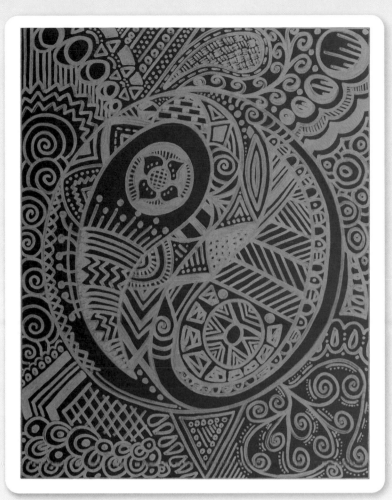

my meditation
STEPHANIE MELISSA DORSAINVIL

14"× 11" (35.6cm × 27.9cm)
Silver metallic Sharpie paint marker on black gloss paper

This tangle pattern was created because I feel the yin-yang sign is a strong symbol that represents unity and balance, which this world can use a lot more of. I've always wanted to do something that alleviates stress and worry. Though my art, I hope I can help people realize the beauty in this world. It's all around us.

1 Start with the outline of a yin-yang in the center of your canvas.

Try to use well-connected lines that flow together, making it unnoticeable where you lifted your marker and started again. (Remember this throughout the whole piece.)

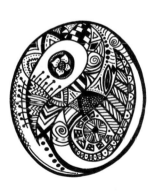

2 Begin filling in empty spaces with dots, stripes, swirls, shapes, anything. Vary the thickness in your lines to add dimension.

Continue filling in patterns, taking care to consider balance and boldness in keeping with the yin-yang theme.

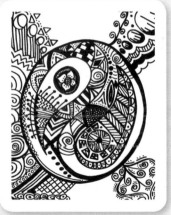

3 Moving to the outer portion of the piece, start in the corners and work everything in together like a puzzle as you fill the canvas.

Visit CreateMixedMedia.com/zendoodle for bonus content.

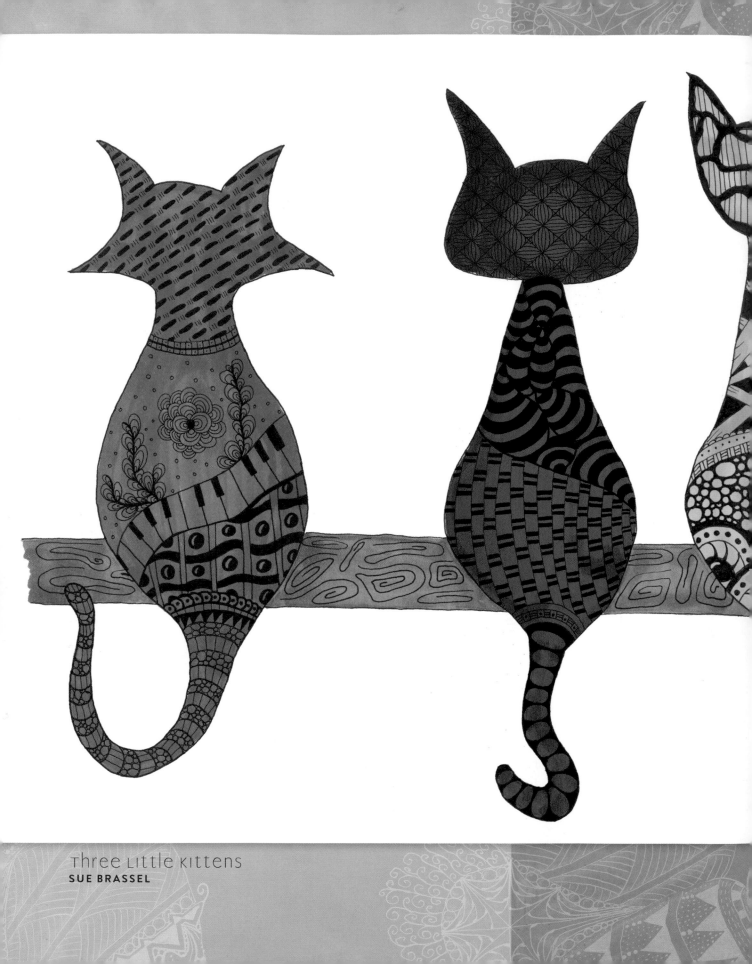

Three Little Kittens
SUE BRASSEL

animals & beasts

The art in this chapter kicks things up a notch as basic shapes and forms come together to create beautifully illustrated animals and fantastical creatures. Birds, insects, sea life—even beasts from another world—can be found here sporting a plethora of patterns.

It's clear these artists love the animal form, and we think you'll agree that their unique approach to filling them with inspiring tangles definitely brings them to life! Debra Ann Terry confirms that there's plenty of Zen doodle fodder to be found in nature: "I began doodling a few years ago and found inspiration in the patterns of nature and everyday life. The swirls of a wrought-iron fence, the weave of a basket, the feathers on a bird inspire me to create."

When planning your own Zen doodle designs, considering your own passions—whether they're animals, culture or food (we love food)—is a great way to express who you are, and it provides the perfect jump start for your creations. A Zen-doodled duck? Sure! A tangled Taurus? Why not? If you can sketch it, you can Zen doodle it!

Sue Brassel ©

wings of freedom

LYNNITA K. KNOCH

6¾" × 6¾" (17.2cm × 17.2cm)
Pen, ink and graphite on 150-lb. (320gsm) ultra-smooth illustration artist paper

Moths or butterflies transforming from caterpillars into beautiful creatures with the freedom to fly inspired *Wings of Freedom*.

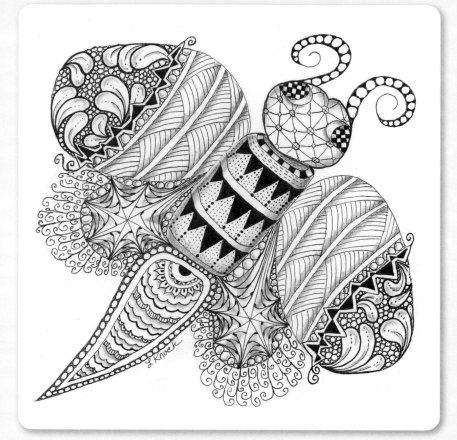

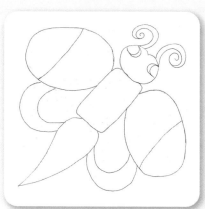

1 Pencil an outline of a moth on your paper, and divide the moth's wings into sections. Add large eyes and antennae curled over the head.

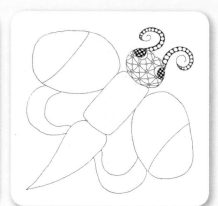

2 Use *Nzeppel*, a grid-based pattern with octagon intersections and squares in the middle, connected by diagonal lines, for the head. Add *Knightsbridge* with small dimensions to create a checkerboard in the eyes. *Pearlz* (circles) complete the antennae.

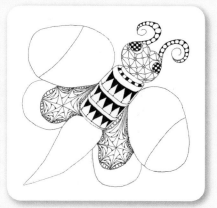

3 Continue filling the body and wings with a variety of patterns. I used three lines of *Queen's Crown*, which are triangles with dots, in the body. The inner lower wing is created with *Betweed*, a star-shaped pattern reminiscent of a spiderweb.

Sign up for our free newsletter at CreateMixedMedia.com.

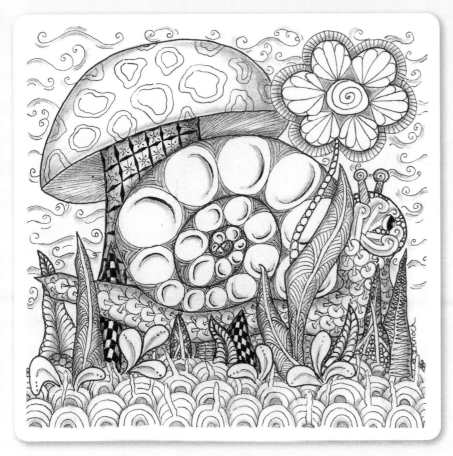

spring excursion
LYNNITA K. KNOCH

6¾" × 6¾" (17.2cm × 17.2cm)
Pen, ink and graphite on 150-lb. (320gsm) ultra-smooth illustration artist paper

I dreamed up *Spring Excursion* to create a whimsical image of spring awakening the world.

1 Draw an outline of a miniature landscape inhabited by a snail. Normally done in pencil, here I used a larger nib pen so the outline would stand out from the tangles.

2 Fill the snail's shell and the flower stem with *Pearlz* (circles). I echoed the shell's pearls so the circles would advance.

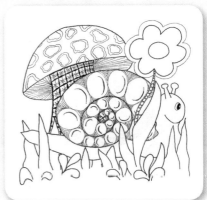

3 In the mushroom stem, use *Buttercup*, a grid-based pattern with a starburst radiating from circles in the center of each grid. Solid, narrow diamond shapes surrounding each grid line create a buttercup flower. The mushroom cap has irregular donut shapes, while straight lines form the bottom of the cap.

chirping on the magic carpet
LYNNITA K. KNOCH

6¾" × 6¾" (17.2cm × 17.2cm)
Pen, ink and graphite on 150-lb. (320gsm) ultra-smooth illustration artist paper

Mixed-media artist Sandy Steen Bartholomew and watching the funny antics of birds inspired *Chirping on the Magic Carpet*.

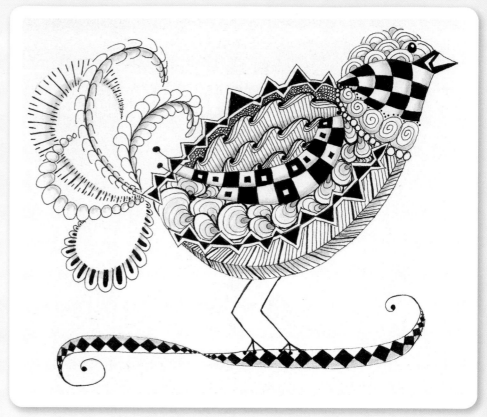

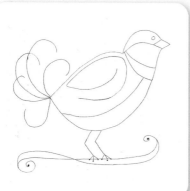

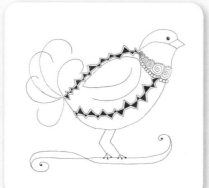

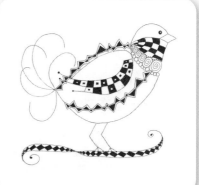

1 Draw a simple bird standing on a magic carpet. Make separate areas for the head, throat, breast and wing. Create your outline in pen or pencil as desired.

2 Use *Rain*, a zigzag pattern with an aura (or echo) around it, on the back and to separate the body from the breast. *Scoodle*, spirals with circles and dots, is a nice embellishment for the throat.

3 In the magic carpet and the bottom of the head, use *Knightsbridge*, which involves creating a checkerboard pattern. A variation of *Knightsbridge* called *Jester* works well for the bottom of the wing. Continue filling in the bird as desired.

Sign up for our free newsletter at CreateMixedMedia.com.

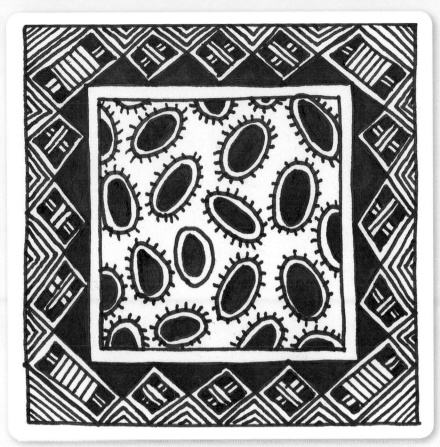

BOX OF BUGS
WENDY C. ZUMWALT

3½" × 3½" (8.9cm × 8.9cm)
Technical pen .08 with India ink on bristol board

Box of Bugs was originally used in a pen-and-ink drawing. The box design bordered the artwork, and the bugs decorated the clothing. It's great to use the doodle as a whole or use parts of it in different works of art.

"Put your butt in the chair, keep your hand moving, smile, play and make sure you have lots of paper."
—WENDY C. ZUMWALT

1. Draw a border around your tile. Add a large square in the middle and give it a border. Make each corner a triangle, and then connect those triangles with an inverted "V." Create a second path of zigzag lines (indicated here with a dotted lined).

2. Fill in the triangles around the center square with a solid color. Inside the center square, draw oval-shaped bugs, then double each line.

3. Fill in the boxes and triangles with lines and solid color. Add legs to your bugs and solid color to their bodies.

BUNNY
BARBARA SIMON SARTAIN

10" × 8" (25.4cm × 20.3cm)
Sakura Pigma Micron pens,
Canson 150-lb. (320gsm)
illustration paper

While searching for new art techniques, I came across some doodles and thought, "Wow! I want to try that!" After drawing a few, I was hooked. Ideas just keep coming to me, along with suggestions from friends. You'll find this fun rope pattern on the bunny's cheek.

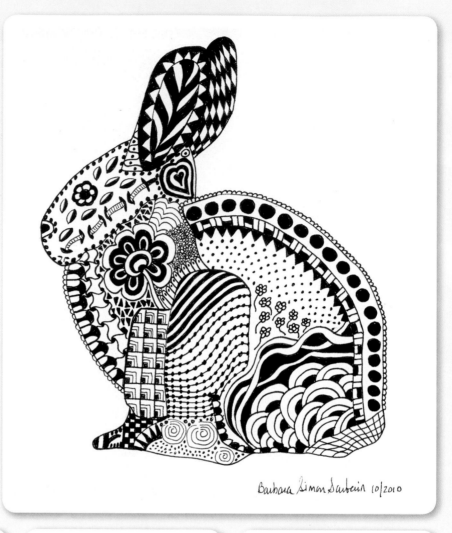

Barbara Simon Sartain 10/2010

1 Draw evenly spaced lines in a curved or straight line, depending on where you're using the pattern.

2 Add a clip on each end.

3 Fill in the clip solid, and add thin lines between the clips.

Sign up for our free newsletter at CreateMixedMedia.com.

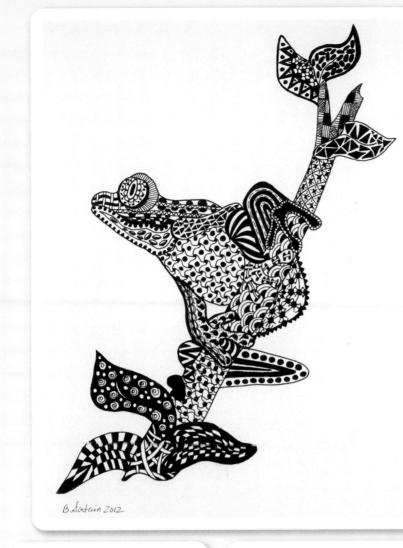

B. Sartain 2012

Tree Frog
BARBARA SIMON SARTAIN

12" × 9" (30.5cm × 22.9cm)
Sakura Pigma Micron pens, Canson 150-lb. (320gsm) illustration paper

This starry doodle is located on the branch right above the tree frog.

"Be fearless when creating your artistic path... explore all the possibilities."

—BARBARA SIMON SARTAIN

1 Draw diagonal lines in opposing directions, creating a grid. These lines can be curved or straight.

2 Add a small, straight line from each corner. Do not connect these lines.

3 In the center of each square, draw a diamond shape and fill it in with black ink.

owl
BARBARA SIMON SARTAIN

12" × 9" (30.5cm × 22.9cm)
Sakura Pigma Micron pens, Canson 150-lb. (320gsm) illustration paper

Look on the lower left side of the owl, just above the perch, to find this doodle.

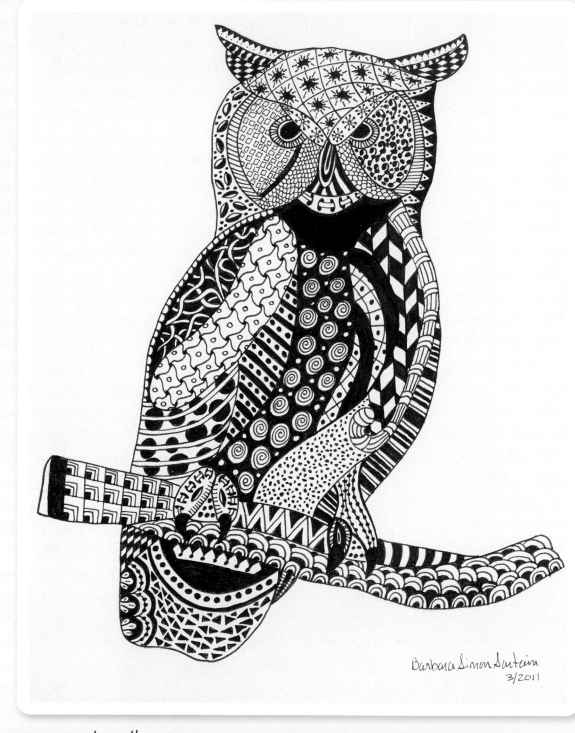

1 Draw 2 curving lines next to each other. Skip a space and draw 2 more. Repeat as desired.

2 Add matching semicircles on both sides of the line pairs, leaving a space between each.

3 Fill in the circles with black ink.

peacock
DEBRA ANN TERRY

5" × 6½" (12.7cm × 16.5cm)
*Colored pencils and markers on
80-lb. (170gsm) drawing paper*

I began doodling a few years
ago and found inspiration in the
patterns of nature and everyday
life. The swirls of a wrought-iron
fence, the weave of a basket,
the feathers on a bird inspire me
to create.

*"The journey
to follow my
dreams did not
begin by taking
a single step but
started with a
leap of faith."*

—DEBRA ANN TERRY

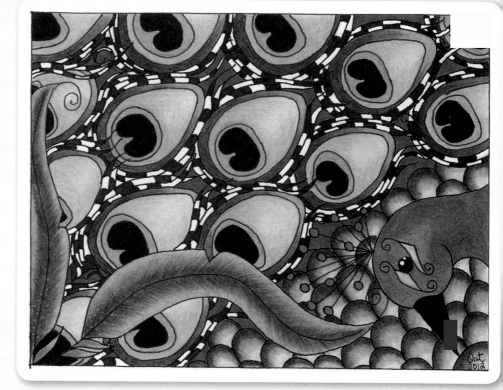

1 | Randomly draw egg shapes
diagonally across two-thirds
of the tile. Keep in mind that
nature is perfectly imperfect.

2 | Turn the tile so the as-yet-
untouched third of the tile is
closest to you. Starting in the
corner, make humps, each row
offset from the one before.
Stop just before you reach the
egg shapes.

3 | Fill in the spaces between the
egg shapes with, what I call,
snakes. Follow the contour
of the egg shape to mimic
peacock feathers. Color and
shade as desired.

Sign up for our free newsletter at CreateMixedMedia.com.

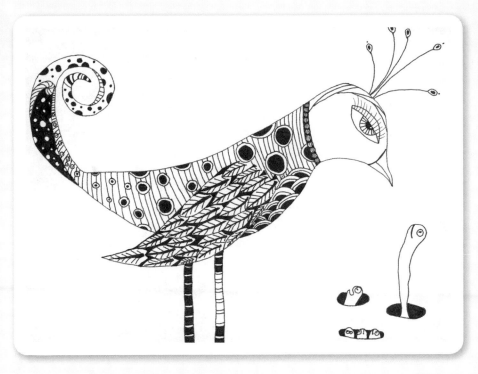

the Early worm Gets the Bird
CHRISTINE ALANE FARMER

8½" × 11" (21.6cm × 27.9cm)
Mead Academie Wire bound Sketch Diary, Sharpie No-Bleed Fine-Point Pen, number 2 pencil, Loew-Cornell blending stump

My love of birds began in the spring when I was about ten years old, just months after having surgery to reconstruct my eardrum. That spring was the first time I remember being able to clearly hear the birds singing and chirping and was the original inspiration for this piece. I did not plan on drawing the worms, but when it seemed the bird was staring off into empty space, I felt I needed to add something.

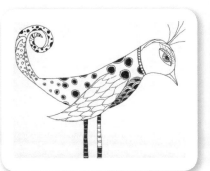

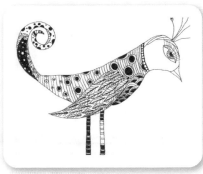

1 Create a basic outline of a bird in pencil. Keep in mind that this is your art and the bird can look any way you want it to.

2 Begin adding details such as circles colored in solid black with rings around them. Additional lines can be added at the tail to give dimension, and the outline of feathers can be drawn on the wing.

3 Add lines on the body and veining on the bird feathers on the wing.

The worms were added as an afterthought, and they are my favorite bit of this drawing. You could add flowers or a baby bird looking back at its mother instead.

surf and turf
DONNA MAY BRUNET

11" × 15" (27.9cm × 38.1cm)

H20 Twinkles watercolors, Koi watercolors, Sakura Pigma Micron pens 08, 02 on Strathmore 140-lb. (300gsm) cold-pressed watercolor paper, pencil

As a child I watched my mother doodle on envelopes while talking on the phone. The longer the conversation, the more intricate and detailed the drawing. Like my mother, I would sketch and doodle on every piece of mail delivered. There were no art supplies or paper available, but I didn't let that stop me. Eventually, Mom had to hide the pencils or get to the mail first before I smothered every inch of the envelope with my own cartoons and doodles. Although my inspiration and love for art blossomed at a young age, the real inspiration and motivation comes from the Lord Jesus Christ. He created me in my mother's womb. Today I'm still creating art, just like my heavenly Father created me to do.

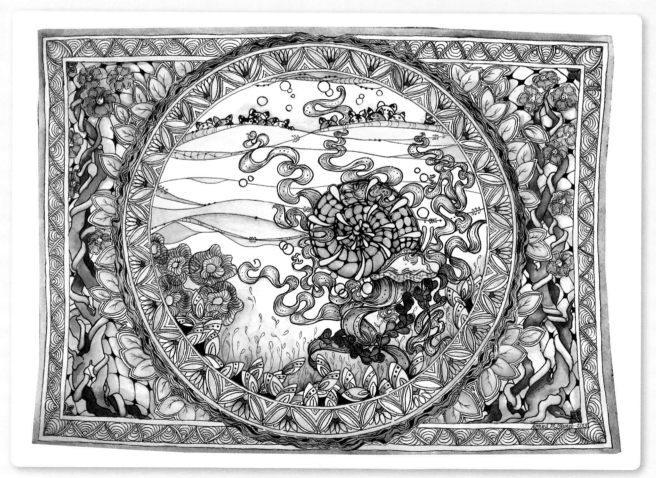

Sign up for our free newsletter at CreateMixedMedia.com.

shell pattern

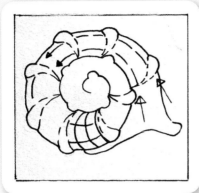

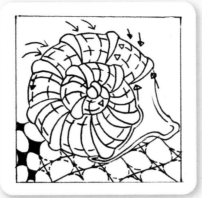

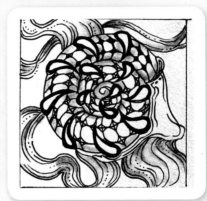

1 Begin with a contour drawing of a seashell. Start from the center and draw a spiral contour line to form the shell. Expand the shape by adding creative elements to the original shape. Using a pencil at this stage will give you room to alter the basic shape.

2 After the contour line has been drawn, outline it with a Micron pen and begin to add details. Create a round, three-dimensional effect by using curved lines inside the shell formation.

3 Add fine lines and small groups of dots as details.

Lastly, shade the areas that appear rounded with a soft graphite pencil and blend them toward the middle using a tortillon. Lighten up the middle range of the drawing with a small, thinly rolled kneaded eraser.

Border Pattern

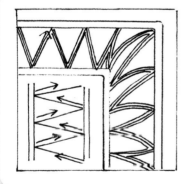

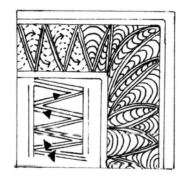

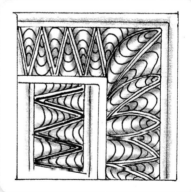

1 This pattern works well as a border and gives room for one pattern to develop into another. Begin by drawing the double lines on the inside and outside of the border. With a series of Vs, fill in the wide empty space.

2 Allow the V pattern to become looser as you add lines. Add small loops inside each "V," making sure these loops are inserted in the opposite direction as the previous curve.

3 To give your doodle a finished look, shade with a soft pencil and use a small, rolled piece of kneaded eraser to remove shading in the center of each "V." Use Prismacolor pencils or pastels in the shaded areas to give the border a three-dimensional effect.

octodoodle

KRISTEN WATTS

11" × 14" (27.9cm × 35.6cm)
*Black Sakura Pigma
Micron Pen on white
Strathmore Mixed-Media
(Vellum) paper*

Octodoodle began with a
curvy blind scribble and
was continued by adding
doodles and patterns to
fill the spaces. As I began
to see the octopus take
shape, I continued to
embellish with added lines
and patterns to extend
the "tentacles."

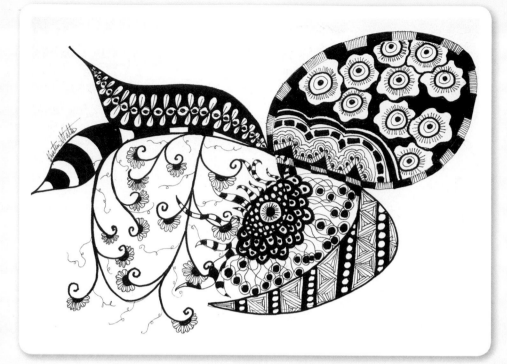

"Always be on the lookout for the presence of wonder."

—E.B. WHITE

1 Start your Zen doodle with a
continuous line that looks simi-
lar to the shape of an octopus.

2 Define your shape by adding
patterns and embellishments to
the original line. This will give
you a defined outline of your
octopus. At this step, you can
also add additional lines to make
your shape even more recogniz-
able (i.e., more tentacles).

3 Continue by dividing up your
empty spaces with different, yet
complementary patterns (i.e.,
some linear, some boxy, some
round, some more random,
etc.). Continue until you are
satisfied with the end result.

Tanglefish
KRISTEN WATTS

8" × 5½" (20.3cm × 14cm)
Black Sakura Pigma Micron Pen on a half sheet of plain white printer paper

After seeing and reading about Zentangle for the first time in an art publication, I had to try it for myself! *Tanglefish* was my very first Zentangle and began as a practice pattern on a piece of scrap paper. I continued to build patterns around the center pattern, and as I did so, *Tanglefish* emerged.

1 Create a basic outline to begin with and a basic larger shape in the middle. These will be the building blocks of the doodle.

2 Building from the central shape, add patterns and doodles to divide the space into smaller shapes within the outline.

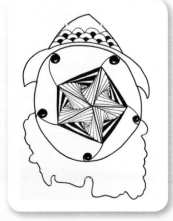

3 Continue to add doodles and patterns within the smaller spaces you created in steps 1 and 2 until you are satisfied with your end result. Most important, just have fun with it!

Lizardoodle

KRISTEN WATTS

9" × 12" (22.9cm × 30.5cm)
Black Sakura Pigma Micron Pen on white drawing paper

I begin most of my Zen doodles with what I call a "blind scribble" (I close my eyes and draw a continuous line with twists, turns and loops). Once I have my scribble down, I begin to fill in the spaces with various doodles and tangles, continuing to embellish until I'm satisfied with the result. I love this approach because it gives me a sense of freedom and playfulness in the process of completing my artwork.

"To draw, you must close your eyes and sing."

—PABLO PICASSO

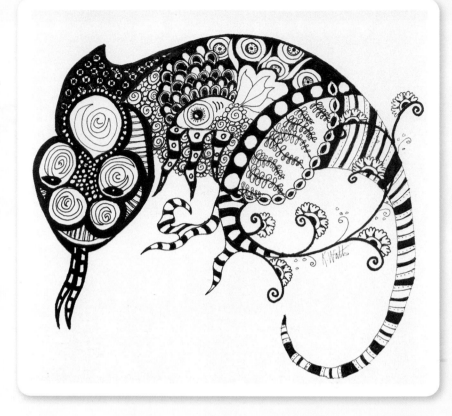

1 | Start your Zen doodle with a continuous line that looks similar to the shape of a lizard. Use this shape, or create your own.

2 | Define your shape by adding patterns and embellishments to the original line. This will give you a defined outline of your lizard. At this step you can also add additional lines to make your shape even more recognizable.

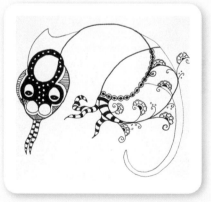

3 | Continue by dividing up your empty spaces with different patterns. You can overlap and layer patterns, fill in around your patterns with black, or leave the space around your patterns white.

Sign up for our free newsletter at **CreateMixedMedia.com.**

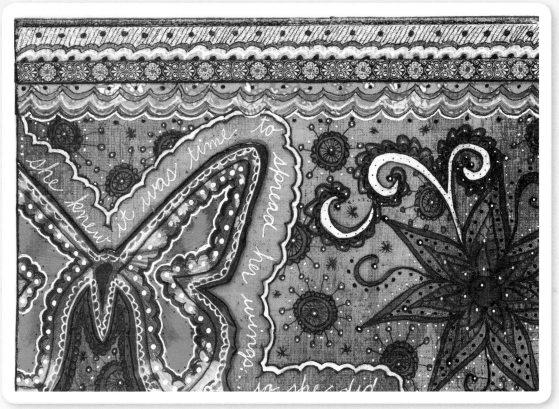

1 Prepare your surface using acrylic paints partially covered by crackle medium. Once the crackle medium is dry, use watered-down black acrylic paint to bring out the cracks in the finish and age the background. Allow it to dry, and then seal the paint with a couple of layers of clear matte spray paint. Using a matte decoupage medium, apply the main design elements.

2 Using a black gel pen, outline the decoupaged elements. Use a white gel pen to add writing around the main decoupaged element.

3 Draw the main doodle element to the piece, using repetitive lines and shapes to create impact in the design. Continue to fill in the background with various shapes and lines, and add more detail to the decoupaged elements. You can leave it this way or fill in the elements using glaze pens, making sure to allow the lines of the doodles to show through the glaze.

ᴅoodle ʙɪʀᴅ
MOLLY ALEXANDER

6" × 8" (15.2cm × 20.3cm)
Paint, pen and ink on canvas

Doodle Bird is a study of positive and negative space in regard to creating detailed doodles. I wanted to give the eye a place to focus without sacrificing the pops of bright color and complex repetitive lines and shapes of the doodles.

1. Prepare your surface with the background of your choice, and apply bold flourish stamps with black, permanent waterproof ink.

 For this background, I layered watered-down acrylic paint onto a plain canvas. After the canvas was dry, I used sandpaper to expose the texture of the canvas and sealed the paint with a clear matte spray paint.

2. Using a black gel pen, draw a bird, keeping it simple with enough room to draw several doodle elements inside the shape. Embellish the flourish stamps with black and white gel pens, and go over the original stamps and the bird outline with glaze pens.

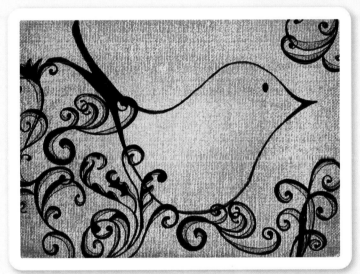

3. Using a pencil or gel pens, start filling in the bird with doodles, making sure to keep the larger elements spaced out to balance the picture, and focusing on repetitive lines and shapes to create continuity. Continue to fill in the bird until it is completely full of doodled elements. You can leave it this way or fill in your elements using glaze pens, making sure to allow the lines of the doodles to show through the glaze.

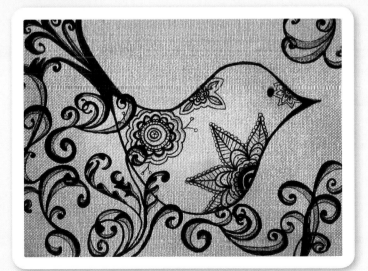

Bird Tangle
SUSAN CIRIGLIANO

8" × 11½" (20.3cm × 29.2cm)
Moleskine watercolor notebook, graphite pencil, Sakura Pigma Micron pens 01, 02, 05 and 08, Winsor Newton Cotman watercolors

Bird Tangle is from a collection of drawings I created between Hurricane Sandy in late October 2012 and Thanksgiving just a few weeks later. All the drawings in the sketchbook were ZIA's (Zentangle-Inspired Art). When I reached the end of the Moleskine, the drawings began to morph into birds and fish.

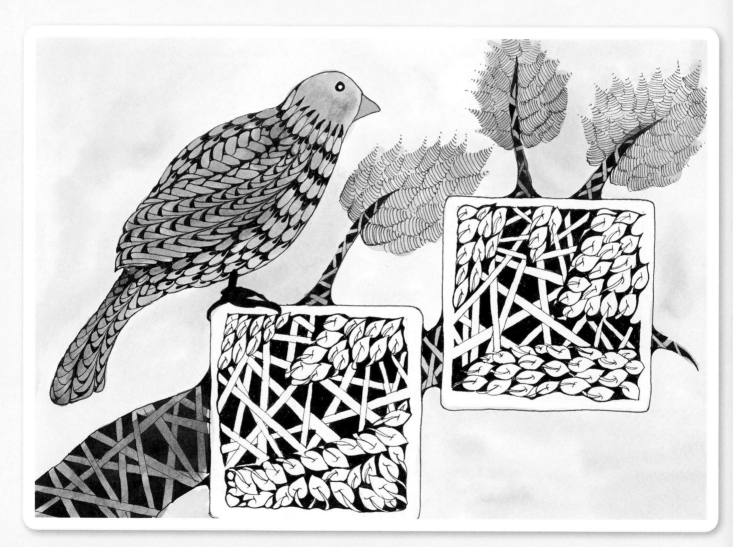

1 Lightly draw with pencil the outline of a bird standing on the 3½" × 3½" (8.9cm × 8.9cm) tile shape. Draw borders on the tiles.

2 To make the bird appear as if it is standing on a tree, use *Hollibaugh* in the tile to create the look of bark on the tree branch.

3 Extend the tangle past the border of the tile and into the rest of the tree. Then fill in the negative spaces with black ink.

4 The *Poke Leaf* tangle works well as the leaves on the tree.
Continue adding patterns to the rest of your image, and then enhance the drawing with watercolor paint.

cheval de cirque

SUE BRASSEL

8" × 10" (20.3cm × 25.4cm)
Sakura Pigma Micron pens and art markers on bristol paper

This was drawn for a little girl who loves her horse. The only requirement I was given was to use aqua and brown. This was a lot of fun, for I was once a little girl who loved my horse.

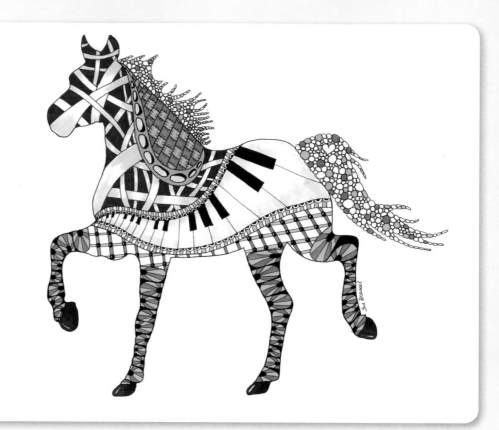

1 Start with an outline of an animal or shape. Begin filling sections with various patterns. In this case, the legs were a challenge because I wanted to use a pattern that didn't look like the horse had socks on.

2 Use a keyboard pattern across the bulk of the body. The size of the keyboard is easily adaptable for the natural curves of the horse's body.

Continue adding complementary patterns to the other sections of the animal.

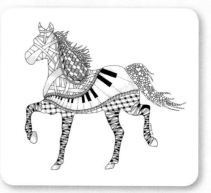

3 With Copic markers, you can shade, as seen in the rubber band design and keyboard. You could also color with markers and shade with pencil when the ink is dry.

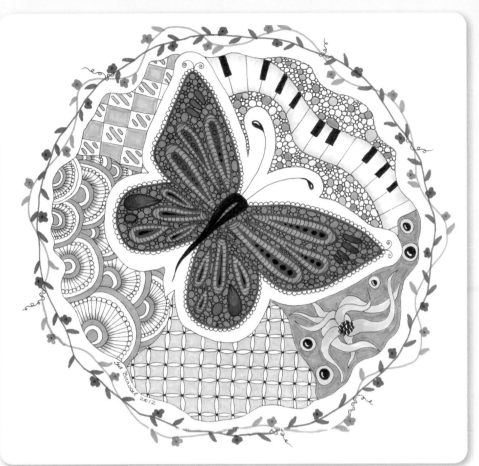

butterfly song
SUE BRASSEL

12" × 12" (30.5cm × 30.5cm)
*Sakura Pigma Micron pens and
art markers on bristol paper*

*"If you want to
realize your
own dreams,
put it out there
and then get
out of your
own way!"*

—SUE BRASSEL

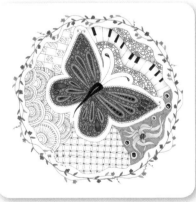

1 | Start with a simple but colorful butterfly on bristol paper, which is made for markers. Using fine-point Sharpie markers and Micron pens, add designs and colors to your butterfly.

2 | Add a little vine-and-flower border to give the butterfly a space in which to fly. To get the circle perfect, use a saucer or other round object and lightly trace with a pencil. You can erase the pencil after your vines are complete and copied with ink.

3 | Now fill in the middle with more doodles and color. I outlined the butterfly first so it wouldn't get lost. In nature butterflies like to blend in, but not in my doodle!

three little kittens
SUE BRASSEL

8" × 10" (20.3cm × 25.4cm)
Sakura Pigma Micron pens and art markers on bristol paper

These three little kittens couldn't care less about their mittens! They are way too funky and cool. Kittens just seem to lend themselves to doodling.

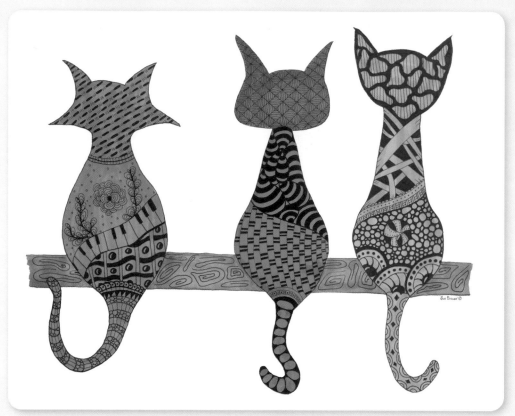

1 Draw your outline and begin to fill those plump little kitties with fun patterns.

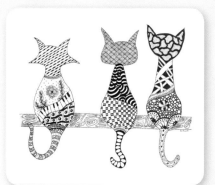

2 Finish filling the kitties with patterns. The kitties were floating on the page, but adding a plank of wood makes them grounded and brings them together. You could leave them black and white with some pencil shading. . .

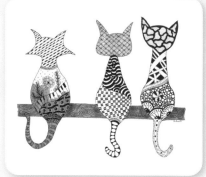

3 Or add color. Fill in the outlines with doodles and color on top, as I did here, or you can color the outlines and then fill in with doodles. Either way, make sure the first layer is completely dry before starting on the next.

I loved the look of coloring the kitties with one color.

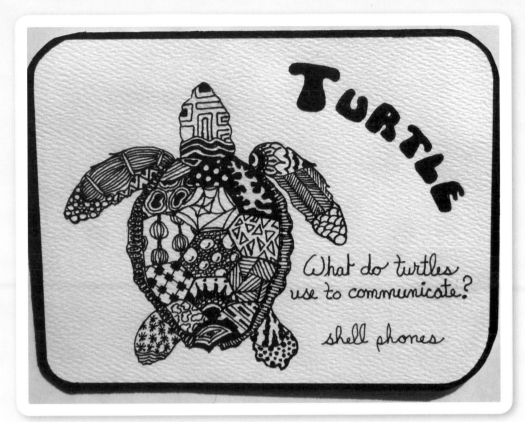

What do turtles
use to communicate?

shell phones

turtle
JUDITH E. STROM

3⅞" × 5" (9.8cm × 12.7cm)
*Black Pilot Precise V5
extra-fine pen on water-
color paper*

This is one of the pages
in an alphabet book I
created for my grand-
son. Each letter/page
has an animal that is
filled with tangles. Most
of the pages also have a
limerick, joke or riddle
pertaining to the animal.

1 Create a rough form of the page getting a balance between the animal outline and the text. I used Photoshop Element to create this initial image.

2 Once I was satisfied with that, I transferred the outlines to watercolor paper. Divide the turtle's body into spaces that can be used for tangling.

3 Fill each space on the turtle's body with a different pattern. Add a handwritten riddle and draw the border on the page.

Drangle
MELODIE DOWELL

11" × 8½" (27.9cm × 21.6cm)
Brown drawing paper, Sakura Pigma Micron pens, colored pens

My inspiration for this was my love of dragons. I started out planning to crosshatch most of the dragon, but I mostly used line work. When I create animals, I try to follow their muscles and body shapes. For the instructional tiles, I used one of his fins coming off his head.

1 First, draw the fin shape and put in the dividing lines.

2 Draw a wavy line in one direction in the first section. Then draw the same wavy line in the next section but going in the opposite direction—one up, one down. Continue to fill in the sections this way.

3 Use your pencil to shade the wavy lines, giving them definition. You can also use a bold pen to darken the lines around the fin to make them stand out more.

FISH
MELODIE DOWELL

9" × 12" (22.9cm × 30.5cm)
Pencil and Sakura Pigma Micron pens on Strathmore drawing paper

I am sixty-seven and have been retired for several years. I turned to art to have something to do. I also raise fish. Hence, the inspiration for this picture. The instructional tiles focus on the gills.

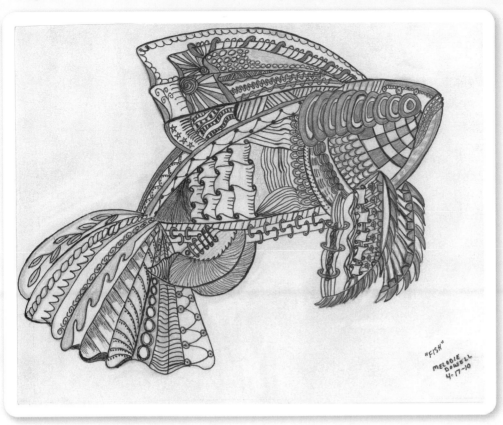

1 First, draw 2 parallel curved lines. Then put a row of circles down the right side.

2 Draw curving lines under each circle like auras or echoes.

3 Finally, add lines under the circles to continue the look of gills. Follow up with pencil shading to make your picture more interesting!

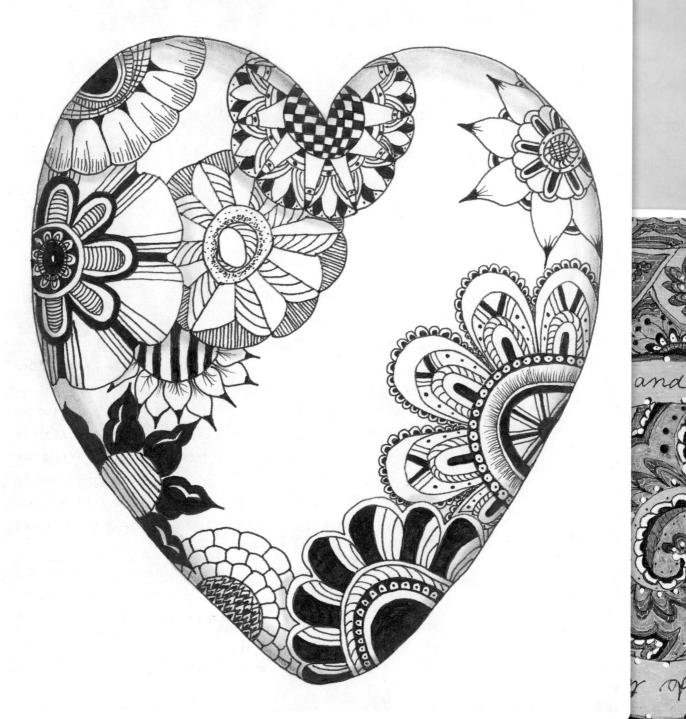

In My Heart a Garden Grows
CHRISTINE ALANE FARMER
circle of friends
MOLLY ALEXANDER

chapter four

friendship
& love

As you probably guessed, this final chapter has plenty of doodle love to go around. Hearts abound and sentiments of friendship are found, but it's the Zen doodle art itself that is, no question, most profound!

Who says Zen doodling can't bring out our romantic side? We agree with Kathie Gadd: "To lose yourself in a Zen doodle is to find your heart's desire." While we may not be able to get a doodle to pay for dinner and a movie, we can probably appreciate the value of Zen doodling coming to the rescue the next time we're stumped for Valentine ideas.

What about the BFF in your life who could use a little cheering up? We bet she'd love a tangled tribute, handcrafted with care and prompted by the great inspiration you're going to find in this chapter.

Love rules, but it's even sweeter with a doodle!

Heart Ablaze

ANNE GRATTON

3½" × 3½" (8.9cm × 8.9cm)
*Zentangle® tile, pencil, medium-point
Faber Castell Pitt Artist pen in Dark
Sepia*

I was inspired by an *Opus* Zentangle pattern I saw in a book. I drew it and then drew a simple heart shape. As I look back, this Zen doodle was drawn on my son's eighteenth birthday. I was subconsciously thinking of him and how proud I was of him! Love you, Ian!

"Don't be afraid to let your art evolve!"

—ANNE GRATTON

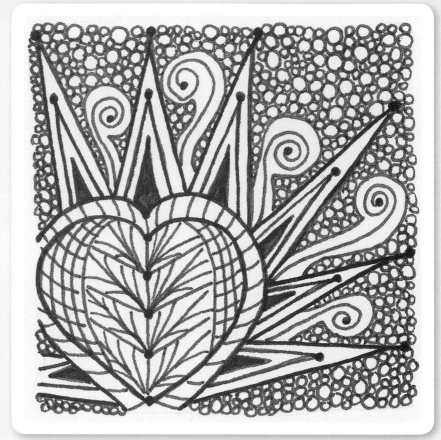

1 Start by lightly drawing a pencil border around the Zentangle® tile. Using a pen, draw in the basic shapes.

2 Decide what pattern you will use in the open spaces. Remember to keep the pattern simple in smaller spaces; otherwise the pattern will run together. Not every space needs a pattern; some can be completely filled in or left open. It is always helpful to rotate your tile while working on it.

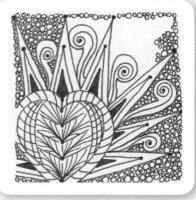

3 Try to use patterns a couple of times in your piece. Hold your tile away from you. Are there any places that blend in too much? Those are the areas to make bolder by carefully going over the lines to make them darker. Visually, different line widths look better.

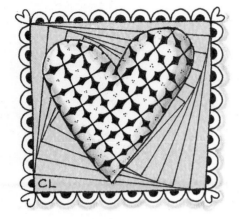

pink Heart
CATHERINE LANGSDORF

4¼" × 4¼" (11.4cm × 11.4cm)
Pink dye-based ink pad and hand-carved rubber stamp, Sakura Pigma Micron pens 01, 005 and soft pencil on Canson bristol paper

This small heart piece was created as a sample for a class to demonstrate how to incorporate stamps with line patterns. I love how a simple heart image can be transformed into a piece of art with simple strokes of the pen. This piece was inspired by the Zentangle® method of pattern drawing.

1 Using a soft pink dye-based ink pad, stamp the reverse heart image.

2 Using a 01 micron pen, outline the heart and the square. Place a small heart at each outer corner of the square. Add the simple half-circle pattern around the complete square.

3 The pattern inside the heart begins by drawing lines with the 005 Micron pen to fill up the inside with a grid. The next step is to create a small 4-petal flower inside each square. Finally, add 3 small dots to the center of each flower.

Add a touch of pencil shading.

A Full Heart
STEPHANIE ACKERMAN

4" × 3½" (10.2cm × 8.9cm)
Prismacolor Premier markers on Strathmore smooth bristol

"create a life that reflects your dreams. live a life that defines your purpose."

—STEPHANIE ACKERMAN

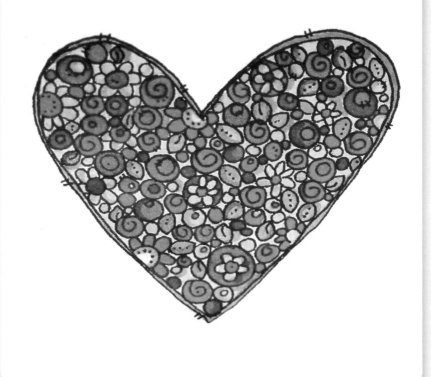

1. Start by drawing any size heart. Begin filling the heart with designs by drawing a cluster of flowers, a few circles and a few leaves in the middle.

2. Continue to add clusters of flowers, circles and leaves until the heart is full.

3. Add a rough second outline around the entire shape, and add color as desired.

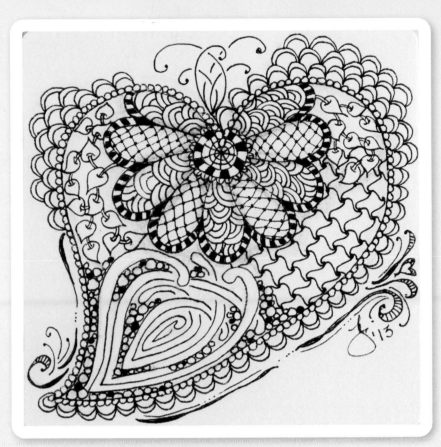

HEAVENLY HEART
KATHIE GADD

3½" × 3½" (8.9cm × 8.9cm)
Zentangle® tile, Sakura Pigma Micron Pen 01

Heavenly Heart is special to me in that it was drawn at a time when I took a leap of faith believing and trusting in myself. It's a reminder that my heart has angel wings and is taking flight into new adventures, protected and loved along the way.

"To lose yourself in a zen doodle is to find your heart's desire."
—KATHIE GADD

1. The first step is to draw the string which in this case is the outside design of the heart and a large flower at the top for some weight.

2. Add the heart-shaped *Mooka* pattern for the perfect echo at the bottom. Incorporate a curved pattern along the right border to soften the edge.

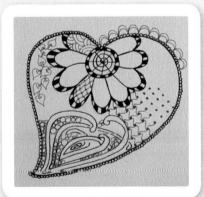

3. The next step is to choose designs with a light and airy feel to fill in the remaining empty spaces. Then add double scallops for the wings along the top border. Add swirls and dots around the outside edge to create a feeling of motion.

in my heart a garden grows

CHRISTINE ALANE FARMER

11" × 8½" (27.9cm × 21.6cm)
*Mead Academie Wire bound sketch diary,
Sharpie No-Bleed Fine-Point Pen, number 2
pencil, Loew-Cornell blending stump*

I have an "angel" that leaves me hearts. I never know where they will appear: in my cereal bowl in the form of a cornflake, a water droplet, a rock found near a stream. So what better way to say thank you to my "angel" than to draw a heart filled with flowers.

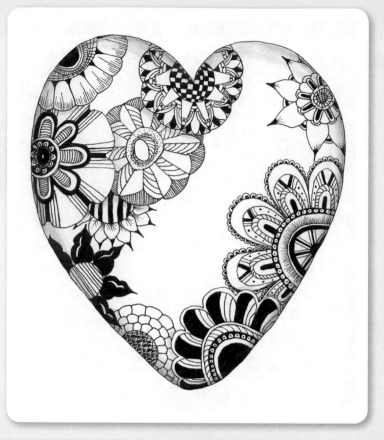

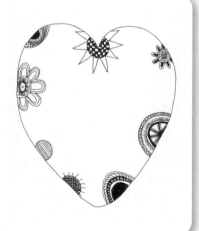

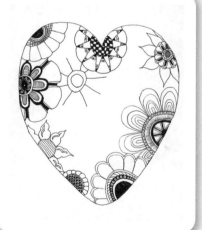

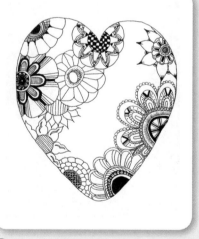

1 Using pencil, create an outline of a heart by drawing two circles side by side. Then connect the circles with the desired V shape at the bottom. Erase the extra lines. Draw a series of half and semicircles and fill them in with checkerboard designs, lines, grid designs and a wagon wheel design.

2 Include additional detail and layers of petals to the first set of flowers. Overlapping them gives a sense of dimension and depth. Draw a wheel-and-spokes shape for the beginning of another flower.

3 Let your imagination go wild and create flowers never seen on this planet.

When the flowers are complete, add shading around the edges to give a sense of depth and dimension, making the heart appear rounded.

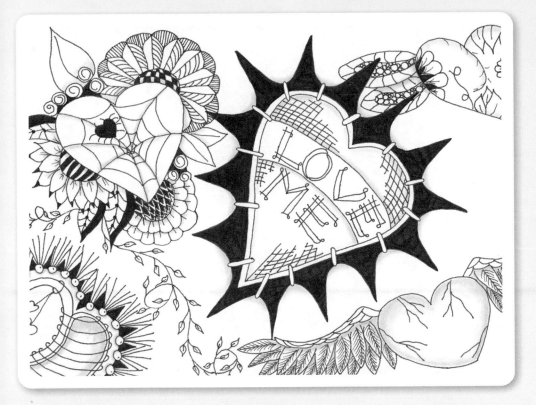

LOVE (ALL OF) ME
CHRISTINE ALANE FARMER

8½" × 11" (21.6cm × 27.9cm)
Mead Academie Wire bound sketch diary, Sharpie No-Bleed Fine-Point Pen, number 2 pencil, Loew-Cornell blending stump

I am blessed to have a wonderful husband and three awesome kids. We love each other, hairy warts and all. The notion of being loved top to bottom, inside and out, and Valentine's day approaching were the inspiration behind this Zentangle.

1 Draw some basic outlines of hearts with some intentionally running off the edges of the paper. Begin embellishing them with positive and negative images, such as wings and spider webs.

2 Continue developing the images by adding flowers to the spider web heart, a pretty, dangly charm to the hole in the hairy heart and feathers to the winged heart. Add stylized lettering to the central heart image.

3 After the desired places and spaces have been designed, add shading. The shading gives the drawing a sense of depth and dimension. The shading on the winged heart is to give the appearance of stone, in keeping with the positive and negative theme.

Dreamworld
JAY WORLING

7" × 4½" (18cm × 11.5cm)
A5 sketchbook cartridge paper, black
Artline 220 pen (0.2), graphite pencil

This piece evolved from finding out about using a string to start a doodle or Zentangle. I have always been interested in how ribbons and fabric fall, so when my curly line appeared on the page as a starting place, I worked from there, turning it into a ribbon and then adding the other elements. This was the result.

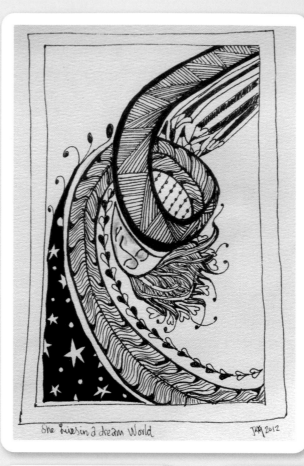

1 Using a pencil, lightly draw a curly line on your page.

2 Draw in 2 lines on either side of the original string. Thicken the line on the front half, and use a crosshatching pattern to fill it in. On the back half, use a different pattern to indicate the back of the ribbon. Remember, you can turn your drawing around to make it easier to follow the patterns.

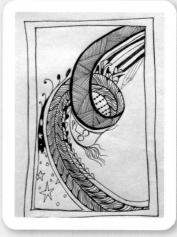

3 Draw in other elements such as the pencils at the top and the stars and dots in the bottom corner. If you want to add in a face like in this drawing, it is easier to turn your picture upside down and draw it than to try to draw the face upside down. Add shading to the face to give it definition.

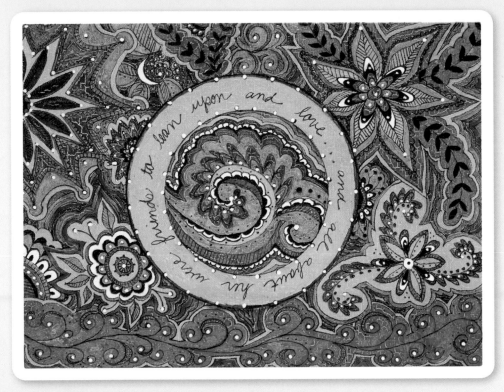

circle of friends
MOLLY ALEXANDER

6" × 8" (15.2cm × 20.3cm)
Paint, pen and ink on canvas

I wanted to create a "wow" piece with lots of color and detail incorporating one of my favorite quotes: ". . . and all about her were friends to lean upon and love" from *Little Men* by Louisa May Alcott.

1 Prepare your surface with the background of your choice, and draw in the center element using black gel pens. I ran out of matte spray paint and used a thin coating of hair spray to seal the paint. The result, as seen in the final piece, is a beautiful crackle effect with the glaze pens.

2 Start by drawing larger design elements, making sure to space them out to balance the picture. Focus on repetitive lines and shapes to create continuity in your design. You can use a pencil first, or move straight to using the gel pen to draw the shapes.

3 Continue to fill in the picture until it is completely full of doodled elements. You can leave it this way or fill in your elements using glaze pens, making sure to allow the lines of the doodles to show through the glaze.

Girl Tangle
AMANDA TROUGHT

3½" × 3½" (8.9cm × 8.9cm)
Pen and ink on cardstock

To create this tile, I initially had been playing around with faces and was trying to get really girly images. I started playing about with shapes, and then with the hair, and I realized that you could get some amazing effects.

"Don't ever limit yourself and be boxed into a narrow way of thinking. Take time to explore and push the boundaries. It will help you grow."

—AMANDA TROUGHT

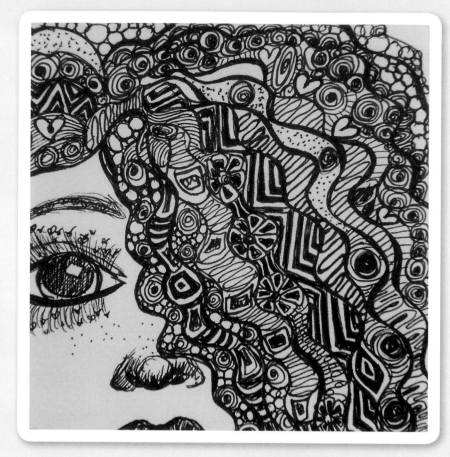

1 Start by drawing the side of a face and hair, leaving space where you would potentially put some patterns. Don't worry about what designs you are going to use. This just helps with placement.

2 Using your pen, go over the pencil marks and start thinking about what designs you could add to the picture.

3 Take a section at a time and have fun adding different designs. Look at patterns around you and try to incorporate them into some of the spaces.

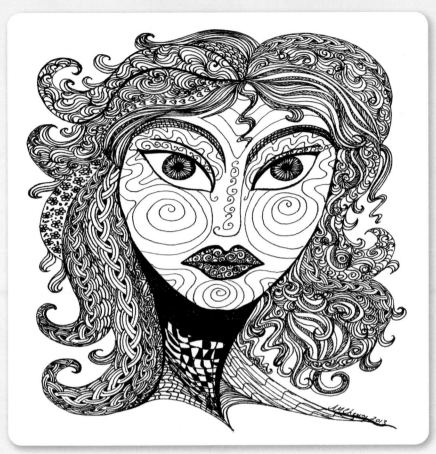

goddess doodle
ANN-MARIE CHEUNG

10" × 8" (25.4cm × 20.3cm)
Ultra-fine permanent marker on cardstock

Doodle artist Gail McNaughton's Zentangle work inspired me to research and start creating my own doodles. My approach to Zen doodling is rather organic, fluid and free-forming, definitely nonlinear. I begin by drawing the outline of something like a face or an object, divide it into sections and then start doodling away. Designing the Celtic braid pattern came naturally as an addition to the goddess's hair.

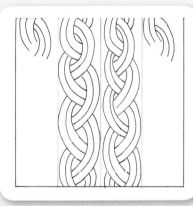

1 Starting from the top of your page in one section, draw 3 curved lines on the left and 3 curved lines on the right. Continue drawing sets of 3 curved lines on the left and on the right until you come to the bottom of your tile, just like you are braiding hair.

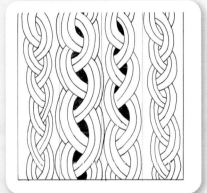

2 Go back and touch up the lines so there are no breaks.

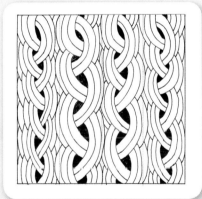

3 Color in the centers, and add more curved lines around the outsides of the braid.

karen's hope
SUE BRASSEL

10" × 8" (25.4cm × 20.3cm)
Sakura Pigma Micron pens and art markers on bristol paper

Breast cancer took the life of my dear friend, Karen. I created this kitty to honor her and help her twin nieces raise money for breast cancer research. There is nothing more satisfying than when you can create a work of art that also helps bring awareness to an issue near and dear to your heart.

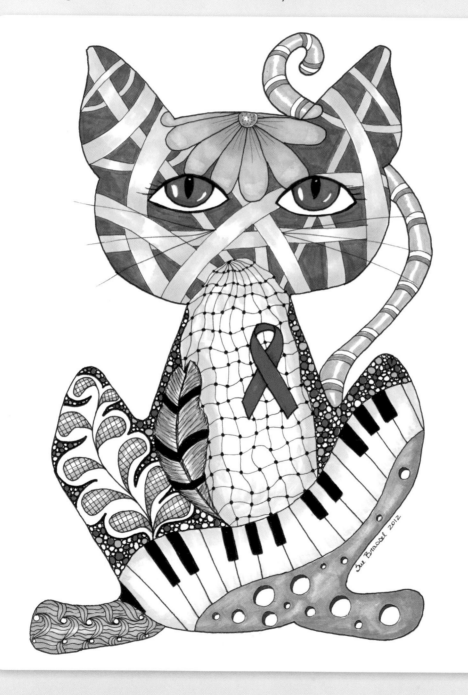

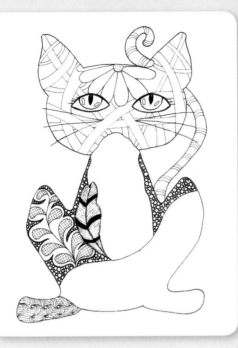

1 Start with an outline of whatever creature you have rattling around in your head. Section off areas to fill with patterns using Micron pens.

2 Unleash the doodles! You'll end up with a great black-and-white piece of art. At this point, you can go in with a pencil and shade areas to create more contrast.

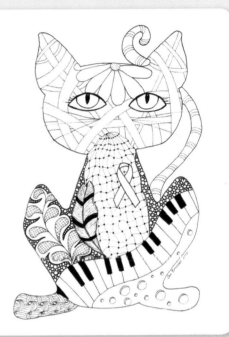

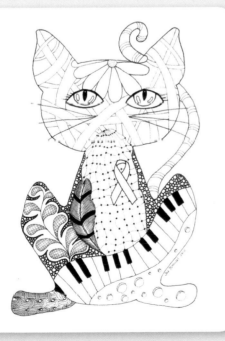

3 Black and white is nice, but get out your markers or colored pencils and watch your doodle come to life. Make sure the ink from the Micron pen is dry before coloring your doodle.

You can see how color brought this little kitty to life. Look at those eyes. They are full of hope, don't you think?

contributors

Stephanie Ackerman
Homegrown1@att.net
Homegrownhospitality.typepad.com
p77 Scrapple Doodle
p112 A Full Heart

Molly Alexander
info@missmollydesigns.com
beautifullybrokenme.blogspot.com
p51 Aloha Doodle
p98 Doodle Bird
p97 Time to Fly
p108, 117 Circle of Friends

Jana Bodin
Jana.tangledpen@gmail.com
Tangledpen.wordpress.com
p72 Mail

Sue Brassel
Crawfordsville, IN
Sue@suebrassel.com
Suebrassel.com
Athens of Indiana Arts Studios and
Gallery
p80, 104 Three Little Kittens
p102 Cheval de Cirque
p103 Butterfly Song
p120 Karen's Hope

Donna May Brunet
Central California
Art Your Wall
805.746.7460
retr2prz@yahoo.com
p92 Surf and Turf

Neil Burley
Perfectly4med@me.com
Perfectly4med.co.uk
p2, 60 Arabian-Style Tangle

Catherine M. Calvetti
Eagle River, WI
cmcalvetti@yahoo.com
catherinemariecalvetti.com
p30 Double Blessing
p31 Roundabout Echo
p32 Teamwork
p78 Winter Tree

Ann-Marie Cheung
AOCA
519.661.8536
info@fgnewmedia.com
annmariecheung.com
p119 Goddess Doodle

Lisa Chin
SAQA
somethinglisa@hotmail.com
somethingcleveraboutnothing.
blogspot.com
p61 ZenFlower

Susan Cirigliano, CZT 9
cirart@verizon.net
p38 Pile of Tangles
p39 Connections
p100 Bird Tangle

June Crawford
acreativedreamer@gmail.com
acreativedreamer.blogspot.com
p42 Doodle 249
p43 Doodle 129
p44 Doodle 240
p45 Doodle 251

Kari Deeble
Deeble Design
Deebledesign@netzero.net
p8 Layers

Stephanie Melissa Dorsainvil
954.610.4937
Stephanie.dorsainvil@yahoo.com
p79 My Meditation

Melodie Dowell
LAA, WSI, Hoosier Salon
Logansport, IN
574.732.1375
vicmeld@comcast.net
flickr.com/photos/49501265@N02/
p20 Kabbage
p21 Clothes Catalog
p106 Drangle
p107 Fish

Christine Alane Farmer
Christine.alane@att.net
Nestfeathersandtwine.blogspot.com
p2, 74 My Metamorphosis
p91 The Early Worm Gets the Bird
p108, 114 In My Heart a Garden Grows
p115 Love (All of) Me

Kathie Gadd
Lavenderchalet@gmail.com
Lavenderchalet.com
p3, 113 Heavenly Heart

Anne Gratton
amgpaints@gmail.com
amgpaints4u.blogspot.com
p69 Flowers 2
p110 Heart Ablaze

Liz Guthrie
White River Junction, VT
p4, 9 Dixie Sunflower

Betsy Jones
CPSA, UK CPS, CPAL
lotusbgallery@yahoo.com
betsyjonesart.com
p53 Mehndi

Lynnita K. Knoch
AQG, AQS, Art Players Mixed-Media Group
480.529.8086
lynnknoch1961@gmail.com
lynnitaknoch.blogspot.com
p36 Ribbons and Rain
p82 Wings of Freedom
p83 Spring Excursion
p84 Chirping on the Magic Carpet

Hannah O. Koch
Artistholiday.blogspot.com
p10 Fish in Flight
p11 Paddle Through Life

Catherine Langsdorf
Hendersonville, NC
828.697.3336
c_langsdorf@yahoo.com
alphabeetangles.blogspot.com/
p2, 71 Blue Highlighted Leaf
p70 C Is for Catherine
p111 Pink Heart

leslierahye
Stephenville, TX
Leslierahye.blogspot.com
p64 Odd Gatherings on a Hillside

G. Blaine Liddick III
The Doris Barton Community Cultural Center
1010 NW 36 Avenue
Gainesville, FL 32609
352.870.4991
liddickgb@gmail.com
liddickgb@yahoo.com
p52 Doodle Two (Circle Patterns)
p54, 76 Doodle One (Quilt Pattern)

Ming-Whe Liou
Mingwhe.liou@telus.net
p2, 63 Seaweeds
p3, 12 Dancing in the Wind
p5, 62 In and Out

Deborah A. Pacé
Tangled Expressions
909.702.8964
dpavcreations@gmail.com
p22 Sharlarelli
p23 Phases of the Moon Zendala
p24 So Retro Zendala
p25 Zendala
p26 Psychedelic Flow
p27 Underwater Seaweed
p28 Googly-Eyed Zendala
p29 Foiled Leaves Zendala
p56 Zendala-Leaves & Fish
p57 Mariner's Star

Kim Pay
Calgary, Alberta, Canada
powdermama@shaw.ca
p37 In the Garden

Jane Reiter
ACGL
517.327.0938
janereiter@sbcglobal.net
tanglewrangler.wordpress.com
Lansing Art Gallery
p73 Fengle Variation

Kim Reitsma
Strathroy, Ontario, Canada
p46 Heavenly Sunshine

Nancy V. Revelle
nan@nansaidh.us
nansaidh.us
p4, 15 Zen Beach
p14 Shells 'N Such
p58 Hugg-N
p59 Woven L

Barbara Simon Sartain
Rocky Cross Studio
rockycrossstudio@gmail.com
rockycrossstudio.blogspot.com
p86 Bunny
p87 Tree Frog
p88 Owl

Elizabeth Snowdon
snowdone@gmail.com
elizabethmsnowdon.wordpress.com
p6 Paths
p40 Untitled
p41 Crawl

Robert H. Stockton
P.O. Box 122
Mukilteo, WA 98275-0122
425.355.3532
scrapbox9@gmail.com
absolutearts.com/scrapbox
everydayikons.blogspot.com
p13 Zentangle #2

Judith E. Strom
p2, 17 Ensemble-Four Tiles
p16 ZT #41
p105 Turtle

contributors continued

Edwina Sutherland
1276 Wellington Street,
Ottawa, Ontario K1Y3A7 Canada
Edwina@edwinadolls.com
Edwinadolls.com
p18 Fabrication
p19 Woven Dreams

Debra Ann Terry
nuleaf@comcast.com
learningtojustbreathe.blogspot.com
p90 Peacock

Leanne Tough
Stitchnmaille.wordpress.com
p47 Lighthouse Tangle

Amanda Trought
Amanda@realityarts.co.uk
Realityarts.co.uk
p118 Girl Tangle

Kristen Watts
artplaytoday@gmail.com
artplaytoday.com
Crazy Lady Gallery and Gifts
Port Orchard, WA
p4, 94 Octodoodle
p68 Ladybug's Leaf
p95 Tanglefish
p96 Lizardoodle

Vanessa Wieland
p33 Sandworms
p34 Spool of Ribbon
p35 Candy Land

Jay Worling
Squashed.mossie@gmail.com
Jworling.com
p48 Bunzo
p49 Zinger 1
p50 Zinger 2
p65 Paisley
p66 Pinwheel
p67 Vases
p116 Dreamworld

Wendy C. Zumwalt
KAC
Wendycurrier1artwork@gmail.com
Wendycurrier.com
Wendycurrier1.etsy.com
p85 Box of Bugs

A Note from the Editors

While this is a book about doodling, many of the contributors were inspired by the Zentangle® method of drawing. You can find out more about Zentangle at the Zentangle website.

zentangle®
www.zentangle.com

The Zentangle method is a way of creating beautiful images from structured patterns. It is fun and relaxing. Almost anyone can use it to create beautiful images. Founded by Rick Roberts and Maria Thomas, the Zentangle method helps increase focus and creativity, provides artistic satisfaction along with an increased sense of personal well-being and is enjoyed all over this world across a wide range of skills, interests and ages. For more information, please visit the Zentangle website.

About Zentangle®:

The name "Zentangle" is a registered trademark of Zentangle Inc.

The red square logo, the terms "Anything is possible one stroke at a time," "Zentomology" and "Certified Zentangle Teacher (CZT)" are registered trademarks of Zentangle Inc.

It is essential that before writing, blogging or creating Zentangle Inspired Art for publication or sale that you refer to the legal page of the Zentangle website.

www.zentangle.com

index

Other fine North Light Books are available from your favorite bookstore, art supply store or online supplier. Visit our website at fwmedia.com.

17 16 15 14 5 4 3 2

DISTRIBUTED IN CANADA BY FRASER DIRECT
100 Armstrong Avenue
Georgetown, ON, Canada L7G 5S4
Tel: (905) 877-4411

DISTRIBUTED IN THE U.K. AND EUROPE BY F&W MEDIA INTERNATIONAL
LTD Brunel House, Forde Close, Newton Abbot, TQ12 4PU, UK
Tel: (+44) 1626 323200
Fax: (+44) 1626 323319
Email: enquiries@fwmedia.com

DISTRIBUTED IN AUSTRALIA BY CAPRICORN LINK
P.O. Box 704, S. Windsor NSW, 2756 Australia
Tel: (02) 4560 1600
Fax: (02) 4577 5288
Email: books@capricornlink.com.au

ISBN-13: 978-1-4403-3210-4

EDITED BY Tonia Jenny and Amy Jones
DESIGNED BY Karla Baker
PHOTOGRAPHY BY Al Parrish and contributors
PRODUCTION COORDINATED BY Greg Nock

about the editors

Tonia Jenny (formerly Tonia Davenport) is the acquisitions editor and senior content developer for North Light Mixed Media. A mixed-media artist and jewelry designer herself, Tonia has authored two North Light books: *Frame It!* and *Plexi Class*. When she's not busy making art, cooking, reading or exploring new ways of looking at the world, you can find her on Facebook and Instagram.

Amy Jones is an associate content developer for North Light Books. You can frequently find her trying mixed-media techniques from the books she edits or reading British literature.

metric conversion chart

To convert	to	multiply by
Inches	Centimeters	2.54
Centimeters	Inches	0.4
Feet	Centimeters	30.5
Centimeters	Feet	0.03
Yards	Meters	0.9
Meters	Yards	1.1

ideas. instruction. inspiration.

Find more doodling inspiration at CreateMixedMedia.com/zendoodle.

These and other fine North Light products are available at your favorite art and craft retailer, bookstore or online supplier. Visit our website at CreateMixedMedia.com

Find the latest issues of *Cloth Paper Scissors* on newsstands or visit shop.clothpaperscissors.com.

Follow us! @cMixedMedia

Follow us! CreateMixedMedia

Follow CreateMixedMedia for the latest news, free wallpapers, free demos and chances to win FREE BOOKS!

CreateMixedMedia.com

- Connect with your favorite mixed-media artists.

- Get the latest in mixed-media inspiration.

- Be the first to get special deals on the products you need to improve your mixed-media endeavors.